Radiant Oils

glazing techniques for fruit and flower paintings that glow

Arleta Pech

NORTH LIGHT BOOKS
CINCINNATI, OHIO
artistsnetwork.com

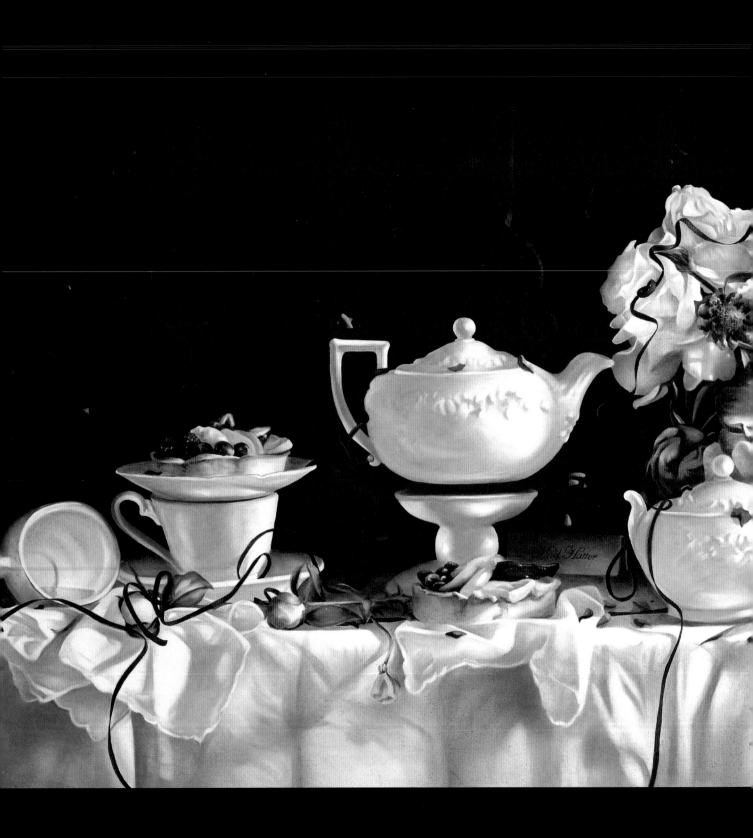

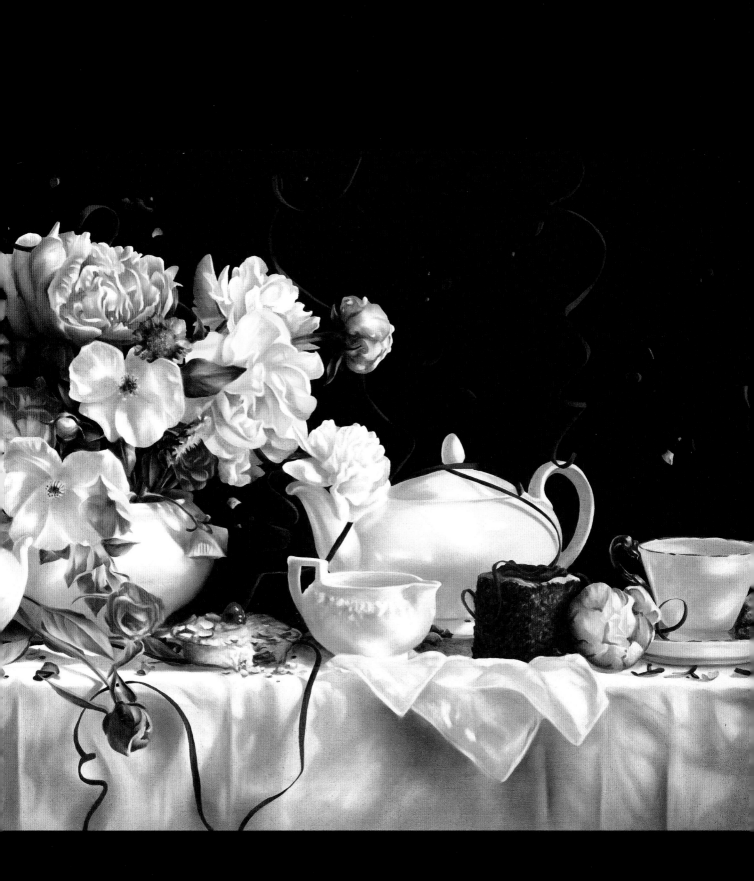

About the Author

Arleta began her fine art painting career in Colorado. She is listed in *Who's Who in American Art*. Her work was represented in the touring museum exhibit "The New Reality: The Frontier of Realism in the 21st Century," and was selected for the Woodson Art Museum touring exhibit for "Birds in Art." She is a member of the International Realism Guild and a signature member of the Rocky Mountain National Watermedia Society. Arleta's images have received international exposure through published reproductions by Mill Pond Press (millpond.com), and through thirty one-woman shows and appearances across the U.S. and Canada. She also authored *Painting Fresh Florals in Watercolor* (North Light) in 1998. Arleta teaches painting seminars in watercolor and oil. You can find her workshop dates, new originals, reproductions and DVD lessons on her website arletapech.com.

Radiant Oils: Glazing Techniques for Fruit and Flower Paintings that Glow. Copyright © 2010 by Arleta Pech. Manufactured in China. All rights reserved. No part of this book may be reproduced in any form or by any electronic or mechanical means including information storage and retrieval systems without permission in writing from the publisher, except by a reviewer who may quote brief passages in a review. Published by North Light Books, an imprint of F+W Media, Inc., 10151 Carver Road, Suite 200, Blue Ash, Ohio, 45242. *media* (800) 289-0963. First Paperback Edition 2013.

Other fine North Light Books are available from your favorite bookstore, art supply store or online supplier. Visit our website at fwmedia.com.

17 16 15 14 13 5 4 3 2 1

DISTRIBUTED IN CANADA BY FRASER DIRECT
100 Armstrong Avenue
Georgetown, ON, Canada L7G 5S4
Tel: (905) 877-4411

DISTRIBUTED IN THE U.K. AND EUROPE
BY F&W MEDIA INTERNATIONAL LTD
Brunel House, Forde Close, Newton Abbot, TQ12 4PU, UK
Tel: (+44) 1626 323200, Fax: (+44) 1626 323319
Email: enquiries@fwmedia.com

DISTRIBUTED IN AUSTRALIA BY CAPRICORN LINK
P.O. Box 704, S. Windsor NSW, 2756 Australia
Tel: (02) 4560 1600; Fax: (02) 4577 5288
Email: books@capricornlink.com.au

Library of Congress has cataloged hardcover edition as follows:
Pech, Arleta
 Radiant oils : glazing techniques for paintings that glow / Arleta Pech. -- 1st ed.
 p. cm.
 Includes index.
 ISBN-13: 978-1-60061-176-6 (hardcover : alk. paper)
 1. Painting--Technique. I. Title. II. Title: Glazing techniques for paintings that glow.
 ND1500.P425 2010
 751.45--dc22
 2009034526
ISBN: 978-1-4403-1160-4 (pbk : alk paper)

Edited by Sarah Laichas
Designed by Guy Kelly
Production coordinated by Mark Griffin

Sweet Perfection (cover) ❧ 32" × 60" (81cm × 152cm)
Oil on canvas
A Proper Time for Tea (title page) ❧ 24" × 68" (61cm × 173cm)
Oil on canvas

Metric Conversion Chart

To convert	to	multiply by
Inches	Centimeters	2.54
Centimeters	Inches	0.4
Feet	Centimeters	30.5
Centimeters	Feet	0.03
Yards	Meters	0.9
Meters	Yards	1.1

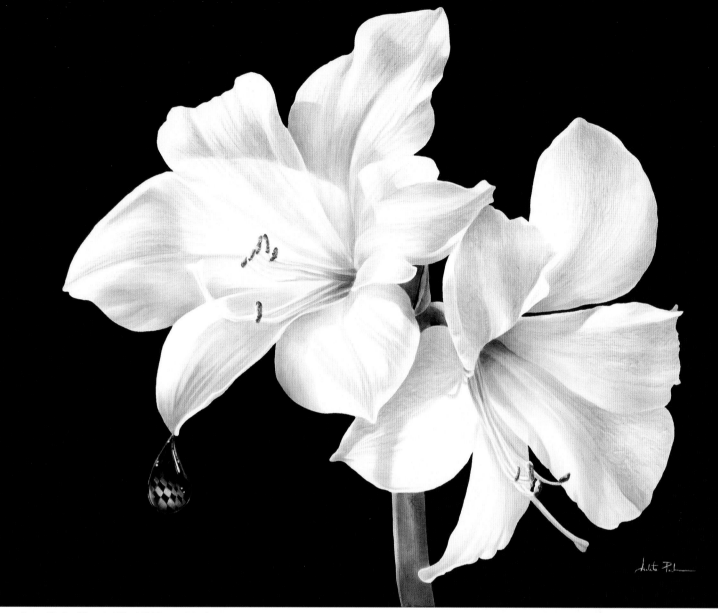

Amaryllis for Alice 🌸 28" × 38" (71cm × 97cm)
Oil on canvas

Acknowledgments

To my best friend, Jane Jones, who has been my
sounding board. I worked out my process to keep my
beloved transparency in this medium, she helped dust
off the cobwebs on my old oil knowledge. To Jamie
Markle, who proposed the book and answered all my
e-mails asking, "Is it time to start writing it yet?" To
my editor, Sarah Laichas, who kept me on track and
gave me feedback when I needed it. To Guy Kelly
for making the book beautiful. To everyone at F+W
Media who has supported my art with articles and has
kept my first book on the market for over ten years.

Dedication

To Bruce, the love of my life, who has shared the ups
and downs of being married to an artist for thirty-nine
years—a feat that deserves its own book. And to my
sons, Tim and Kevin, who shared time from their pre-
cious childhood with the demands of my art career. I'm
so very proud of the men you've become.

Table of Contents

Introduction
page 8

CHAPTER 1
Materials and Equipment
page 10

CHAPTER 2
An Introduction to
Transparent Glazing
page 24

CHAPTER 3
Background Techniques
page 35

CHAPTER 4
The Foundation of
Transparent Glazing
page 40

CHAPTER 5
Painting Subjects
With a Glaze
page 54

CHAPTER 6
Four Demonstrations
page 80

CHAPTER 7
Glazing Techniques
in Action
page 126

Conclusion
page 140

Index
page 142

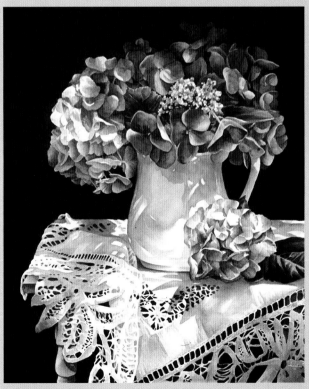

Hydrangea Melody ✤ 22" × 19" (56cm × 48cm)
Oil on board ✤ Private collection

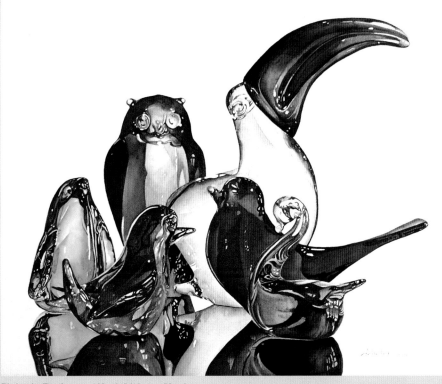

Birds of a Feather ✍ 19" × 21" (48cm × 53cm)
Watermedia on 140-lb. (300gsm) cold-pressed watercolor paper

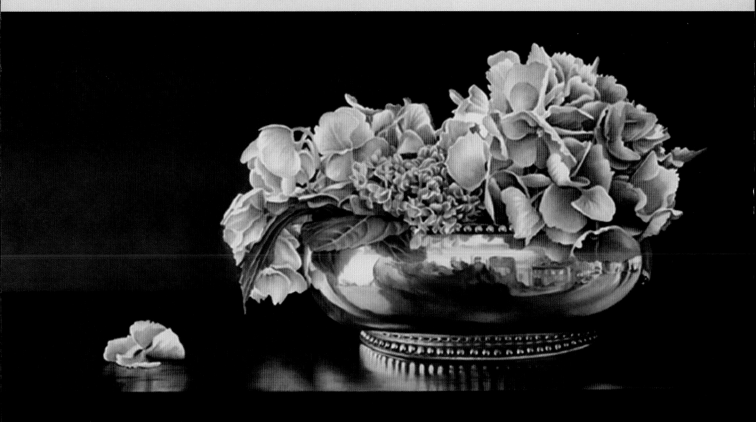

Silver Hydrangea ✍ 13" × 25" (33cm × 64cm)
Oil on board ✍ Private collection

Introduction

My love affair with transparent colors began in 1969 when I was a commercial artist working with layers of colored acetate for mockups and proofs. It was during this time that I realized how much I loved looking through layers of colors on my lightbox. This infatuation grew throughout my watercolor years while I developed my transparent color theory, leading to my first book, *Painting Fresh Florals in Watercolor*. I have continued to refine my theory in my workshops and have even developed a special glazing viewer for artists to help them see and experience using transparent colors.

Sometimes your path for growth as an artist is not evident, and switching to oils was that unseen path for me. In 2001 I began to experiment with other mediums, looking for richer color and more luminosity. I tried working in egg tempera and fluid acrylics for a while, but these mediums lacked what I was looking for.

In 2005 I dusted off my 1970s oil knowledge, but I knew that after working with luminous color for so long I would not use oils opaquely. Instead I used my years of transparent color theory and work with oils as if they were watercolors. I was excited by the level of luminosity I achieved. I found that by using only transparent colors, each glaze stands alone, shimmering and clean with a glow that catches the eye, even in a dimly lit room.

This book is about my passion for luminous color and the process of working with transparent oils. It's also a great resource for

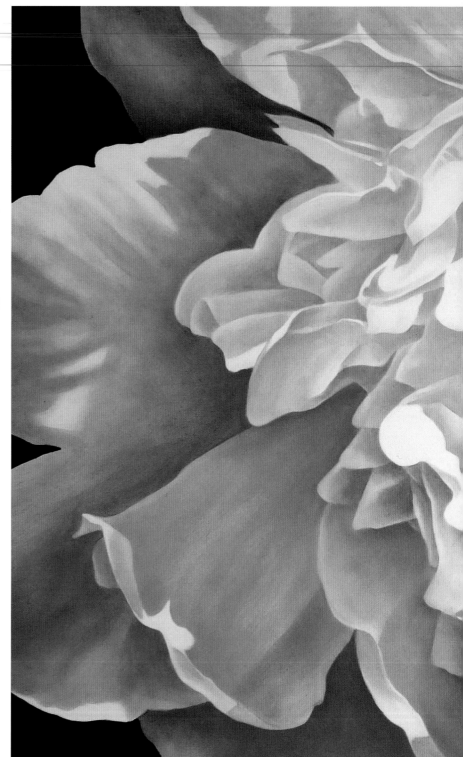

watercolor artists transitioning to oil, or for oil artists who want to explore the beauty of glazing with transparent colors.

This style of painting is called *transparent glazing*; it is completely transparent with only the white of the board or canvas to reflect the colors. If you love realism and luminous color, this book will teach you how to use transparent colors to create paintings that will glow.

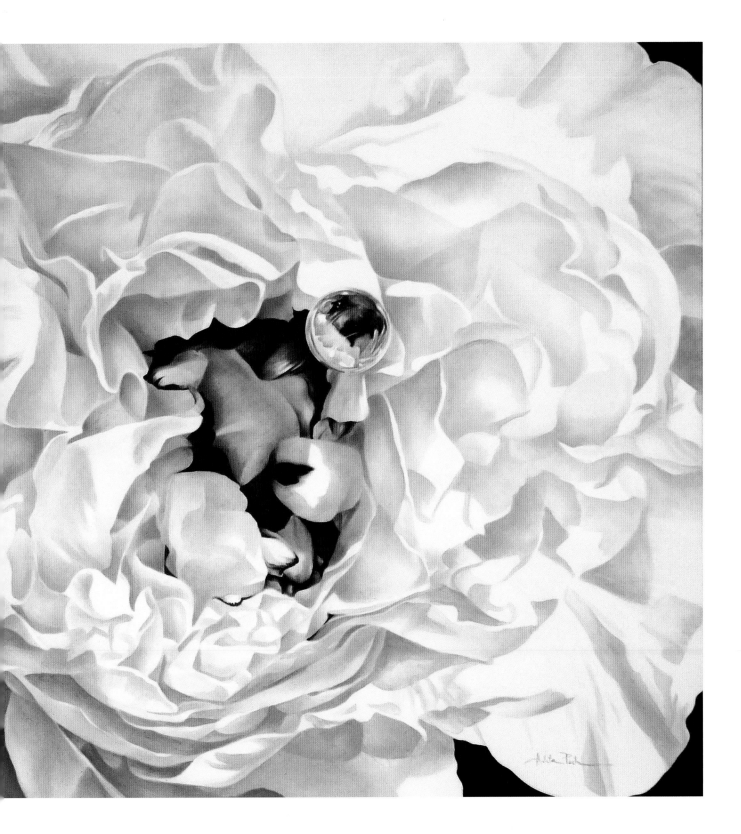

Materials and Equipment

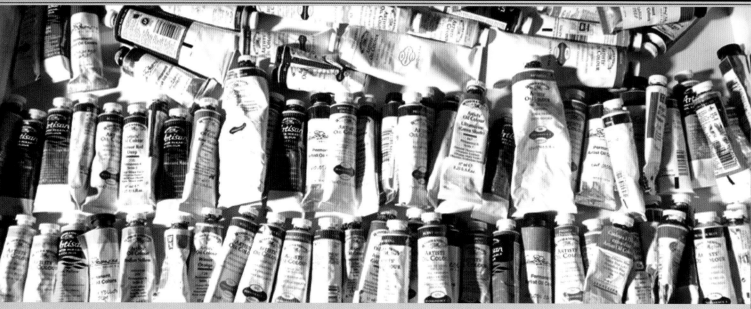

YOU DON'T NEED EVERY COLOR ON THE SHELF OR every brush size to be a successful painter. Though I have a studio full of equipment that has taken years to accumulate, you really only need a few things to get started on the exercises in this book. This chapter discusses the various supplies you'll need—brushes, medium, paint and surfaces—to paint luminously in oil.

My Color Palette

I thought it would be fun to show you my drawer of paint. The list of colors that I use on a regular basis and for all the paintings in this book is on page 29. I have selected my palette from years of experimentation, trying a color here and there or simply playing with a different set of primaries. Try painting with a limited palette until you become more knowledgeable with color theory, then add selected colors for fun.

Brushes and Tools

I have a lot of worn-out brushes that I just can't seem to throw away since they are like old friends. Many times, the purpose and function of these old brushes evolves in ways that I don't expect, then I really can't live without them. Below you'll see the primary brushes and tools that I use in my paintings. I have provided descriptions of each so you know which brush does what.

Synthetic vs. Natural Brushes

I prefer glazing with synthetic brushes because the brush hairs won't break and show up in the thin glazes of oil paint. Mongoose brushes hold their shape for applying delicate glazes and edges. You can't scrub with them like you can with synthetic brushes. I keep many different sizes handy so the size of the brush relates to the size of the shape I'm painting.

My Brushes and Tools

a 1-inch (25mm) mop (mongoose) to smooth out backgrounds

b no. 14 flat (mongoose) to apply heavier paint for backgrounds

c no. 12 flat (mongoose) for thinner backgrounds and blending out

d no. 8 flat (mongoose) for small background areas

e no. 4 flat (mongoose) to get close to an edge of an object in a background and for tiny areas between shapes

f, g, h, i nos. 8, 6, 4 and 2 synthetic filberts to apply glazes

j, k, l, m nos. 2, 4, 8, 16 scrubbers are fabriclike brushes made of nylon; their unbreakable hairs are ideal for blending values in each glaze

n 1-inch (25mm) soft mop for blending and smoothing glazes

o light gray pastel pencil to draw the subject directly on the canvas or board

p sanding pad to sharpen pastel pencils

q retractable eraser to remove unwanted drawing lines on board (this model by Pentel removes both pencil and ink)

r kneaded eraser to pick up pastel dust from the canvas

s palette knife to mix background paint

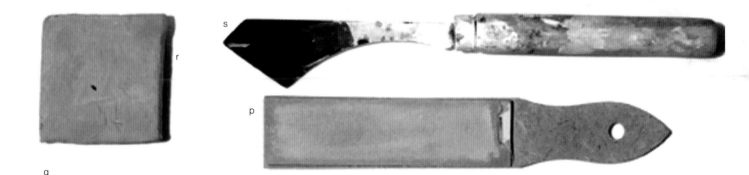

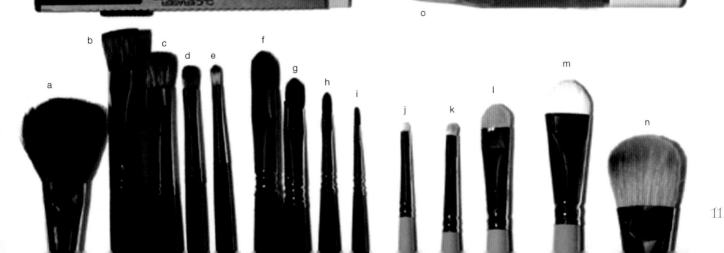

How to Dress a Brush

A key to the transparent glazing technique is using the right amount of paint on your brush and palette. I place my colors in small amounts on disposable palettes to avoid wasting paint. At the end of the day I put them in the freezer to save the paint for more uses.

Using the Right Amount of Paint

This is an example of three no. 4 brushes next to the amount of paint I place on my palette to paint a glaze on a few flower petals. Notice the color marker on the brush handle? These help me to know what color I have on each brush, since I use so little paint that is doesn't show in the brush hairs.

To blend, place a very small amount of Walnut Alkyd Medium by M. Graham & Co. on the palette to keep it from tacking up. Use the edge of the medium only to dress the brush before working it into the paint. If you get streaks on your canvas when blending a value, you have too much medium or paint on the brush.

Mixing Background Paint

Use a palette knife to mix your neutral or semineutral background colors with a small amount of medium to help it dry faster. Mediums are also great for thinning paint into a lighter, more workable value. My favorite medium is Walnut Alkyd Medium by M. Graham & Co. It's an environmentally friendly alternative to typical solvents. See page 15 for a list of other mediums.

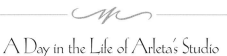

A Day in the Life of Arleta's Studio

One day in my studio might entail a number of tasks: photographing ideas and reference photos, drawing, painting, stretching canvas, varnishing paintings, or boxing and shipping art to a client. I'm a daytime painter, though some artists prefer the evening. I'm usually in my studio from 9:00 A.M. to 5:00 P.M., not including a short break for lunch. A perfect painting day is when I get over twenty brushes dirty.

Other artists often ask me how many hours a day I paint. It's not an easy answer. Most days include at least a few interruptions—calls from galleries, e-mails to students, mailing art or products from my website, or preparing worksheets for classes. If possible, I try to save such matters for after studio hours and group errands so I only have to leave the studio one day each week. The key to success as an artist is time management. It's not so important how many hours you spend painting, it is that all parts of your day support the painting process.

Clean Working Habits

Clean working habits are essential to working with oils and mediums.

Always wash your hands after every painting session and after using chemicals. Keep your hands and work area clean to avoid any unnecessary messes. Have a trash can with a lid nearby to throw away your paint-filled paper towels. I like to keep moist baby wipes near my easel to wipe up any messy moments such as dropping a brush or smudging paint where it shouldn't be.

Cleaning Brushes During the Painting Process

To remove paint from your brush when changing colors during a painting session, work the brush in some walnut oil on the palette and wipe the excess oil on a paper towel. It's best to use that brush with the same color family—reds, blues, yellows—though it does mean having to clean many brushes at the end of the day.

Cleaning Your Brushes After Painting

Figure out a cleaning ritual and follow it at the end of each painting day. The cleaning supplies I use are listed below. To clean your brushes adequately, wipe the excess paint from each brush with a soft paper towel. First, rub the brushes in the walnut oil on the palette and wash them twice in a utility sink. Next, clean each brush with a wash of Murphy Oil Soap and water to get the bulk of paint out of the brush. Finally, rinse the brushes under running water using your fingers, and work brush cleaner through the hairs to remove any remaining paint or medium residue. Wash your hands, then wipe and shape the brush tips on a paper towel and lay the brush flat to dry overnight. This prevents moisture from seeping into the brush's *ferrule* (the metal ring that holds the brush hairs together), helping it to last longer.

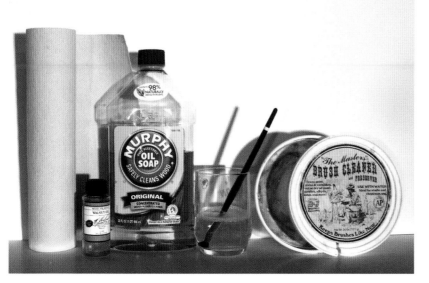

Materials for Brush Cleaning
My method for cleaning brushes is environmentally friendly for healthy brushes and a healthier studio. I clean my brushes in three steps. During painting I dip my brushes in walnut oil and wipe them on a paper towel; after painting I wash them in Murphy Oil Soap; finally, I rub the hairs with a professional brush conditioner. This last step really helps get any lingering paint residue and medium out of the hairs. From left to right: lintless paper towels, Walnut Oil by M. Graham & Co., Murphy Oil Soap, glass jar of oil soap and water, and Masters Brush Cleaner and Preserver.

Selecting a Medium

Transparent glazes are created by thinning oil paint with a medium. With transparent glazes the medium you choose to work with is very important. There are many different mediums available, each with their own properties and drying times. The chart on page 15 discusses some of these differences, but as with anything, the best way to learn which mediums you prefer is to experiment.

Testing Different Mediums

When you explore various mediums, do this simple test. First, prime the brush with the medium by working it into the hair tips of a clean brush. Work the medium into a bit of paint and move the paint on your palette to get the feel of it. Is the mixture creamy or oily? Thick or watery? Some mediums are so oily that when you start to blend the glaze they pull too much paint away, making it difficult to get a smooth look. Experiment with different mediums, letting your glazes dry in between to gauge the full effect of each.

My first choice of oil painting medium is Walnut Alkyd Medium by M. Graham & Co. It is non-toxic and takes little time to help the oil paint dry. In Denver's dry climate, it takes just one day to dry in the studio.

For luminous glazes, it's extremely important to allow each glaze to dry completely before applying the next glaze, or the glazing medium will lift the delicate paint. All mediums (except wax mediums) will dry faster if you place the painting in a confined area or small room and use a heat lamp. (Wax mediums should be kept away from heat.)

Medium Choices

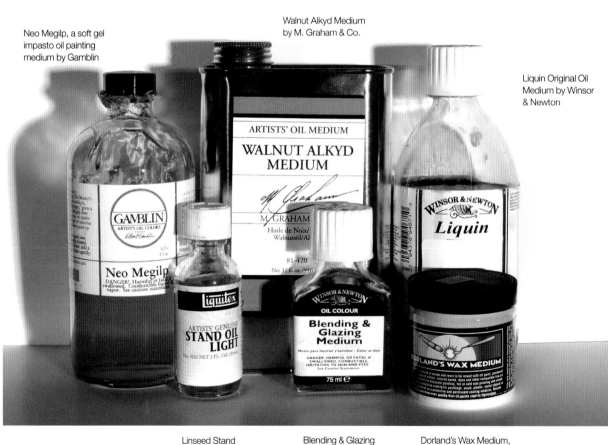

Neo Megilp, a soft gel impasto oil painting medium by Gamblin

Walnut Alkyd Medium by M. Graham & Co.

Liquin Original Oil Medium by Winsor & Newton

Linseed Stand Oil by Liquitex

Blending & Glazing Medium, a mixture of damar varnish, linseed oil and mineral spirits by Winsor & Newton

Dorland's Wax Medium, a wax and resin mixture

Medium Comparison Chart

Mediums have unique properties. Experiment with each one to determine which works best for your working process and location. Humidity plays a big factor in how these mediums dry in different climates.

Name	Odor	Blending	Air-dry time	Heat-lit area	Luminosity
Liquin	some	good	overnight	faster	OK
Stand Oil	strong	slick	over 24 hours	slow	OK
Wax	none	dry	n/a	do not use heat	dull
Walnut Alkyd	none	very good	24 hours	overnight	OK
Winsor & Newton Blending & Glazing Medium	some	good	overnight	faster	dull
Neo Megilp	some	smooth	overnight	faster	OK

A Thrifty Habit

If the medium begins to tack up, refresh the medium on your palette. For best results, use only a small amount at first. Place the medium on your palette using a palette knife instead of dumping it from the bottle. You only need a dime size amount.

Stretching Your Own Canvas

Stretching your own canvas is a great way to save money. All it takes is a few high-quality supplies and a little elbow grease. By stretching your own canvas, you can paint all the way to the edges and display your work without a frame.

Stretcher bars come in many weights and sizes to suit various sized canvases. For large, oversized paintings, heavier stretchers are best for keeping the canvas taut so it won't bow. I recommend using the best quality stretchers you can afford, such as kiln-dried. They are less likely to warp over time.

Materials for Stretching a Canvas
From left to right: A roll of primed canvas, stretcher bars, T-square, wood glue, canvas pliers, staple gun and rubber mallet.

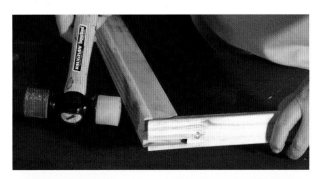

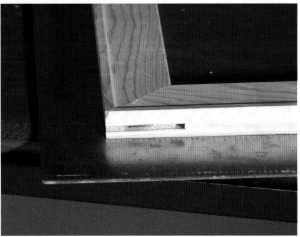

1 Assemble and Glue the Stretcher Bars
Lay the stretchers out on a flat surface and press them together by hand. Use a strong wood glue in the divets and a framing T-square to double-check that each corner is 90 degrees. Gently tap the corners of the assembled frame with a rubber mallet to make sure they are secured together. You can also use your hands to apply pressure to the sides of the stretcher frames to make fine-tune adjustments. Keep a T-square on the corners when making these adjustments to ensure 90-degree angles. Allow the joined stretchers to dry for twenty-four hours before stretching the canvas.

Arleta's Favorite Canvas

I prefer high-quality portrait canvas for my realism paintings. I use Artfix, a French brand of primed cotton duck canvas. Multiple coats of primer make it ready for painting, but it doesn't come stretched.

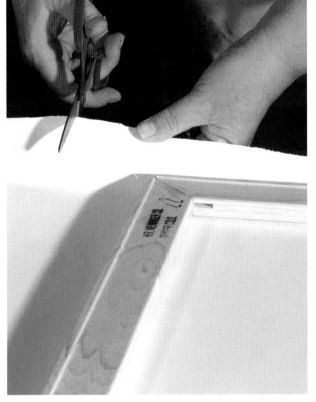

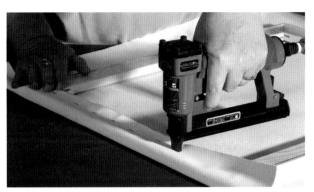

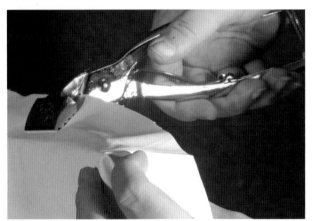

2 Cut the Canvas

Lay the canvas on a flat surface with your assembled frame on top. Allow at least 2½ inches (6cm) of extra canvas per side before you cut. For heavier stretcher bars, allow at least 3½ inches (9cm) per side.

For the two large canvas originals in this book, *Sweet Perfection* and *Sheer Reflections*, I stretched cotton duck primed canvas. To stretch a canvas to gallery standards, cut enough canvas to cover the back of the frame.

3 Stretch and Staple the Canvas

Stretcher bars are hard wood, so getting the staples in can be challenging when you're trying to stretch the canvas at the same time. If you use a high-quality staple gun or one connected to an air compressor, it's much easier.

For a tight canvas, it is best to staple around the frame in a systematic way. Using stretcher bars, pull the canvas tight on one side and staple once in the middle of the bar. Repeat this for all four sides.

Next, staple from the middle of one of the longest sides of the frame to about 6 inches (15cm) from each corner. This will allow enough room to fold the type of corner you prefer—whether for framing or for a gallery-wrapped canvas. Switch to the opposite bracket and continue stapling around the canvas, placing staples about 1 inch (3cm) apart, until the entire canvas is complete.

Watch an Online Video for More Instruction

If you need more instruction or visuals, an Internet search will yield many short videos on how to stretch your own canvas.

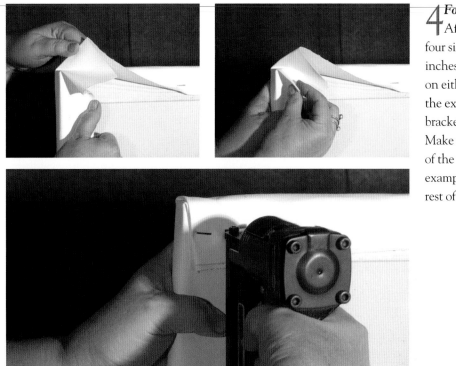

4 Fold the Corners

After you've stapled around the four sides, you should have about 6 inches (15cm) of unstapled space on either side of each corner. Pinch the extra canvas and fold it over the bracket then staple it firmly in place. Make sure you only staple on the back of the frame. The lower image is an example of a stapled corner, after the rest of the frame has been completed.

Painting the Edges of a Canvas

In *Red Wine Decanter*, I painted the brown table edge all the way around the edge of the canvas. This is a way to display your painting without a frame.

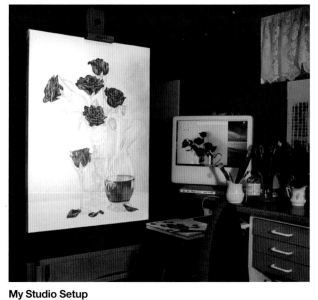

My Studio Setup

Here is an example of a stretched canvas in my main working area. Notice at right is my computer. Since I work from digital photos, I keep them up on my monitor so I can zoom in to detailed areas.

Preparing a Gesso Surface

Preparing your own gesso hardboard is easy and cost-effective. It's best to start with a high-quality hardboard, such as plywood with a birch-panel top layer. The board must be sealed with gesso on all sides to keep it from bowing.

There are also many types of prepared gesso boards available. I recommend the Ampersand brand because it's closest to the texture of the boards that I prepare for myself.

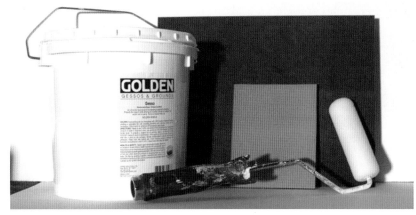

Tools for Priming Hardboard
From left to right: gallon tub of white gesso, untempered hardboard, sanding pad (150 fine grit), high-density smooth 4-inch (10cm) sponge roller with handle.

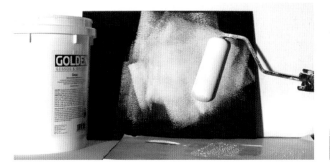

1 Apply the Gesso
Dip the foam roller into a gallon tub of gesso and roll it over a disposable paper palette to coat the roller evenly. Apply a thin coating of gesso to the entire board. Begin at the edges of the board before moving over the rest of the surface to prevent buildup near the edges. Move the foam roller across the painting surface until you hear zero noise from bubbles popping. You can see the gesso smooth out as you roll. Place the roller in a plastic bag between coats to prevent it from drying out.

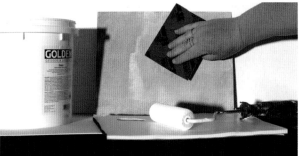

2 Sand the Gesso
Always wear a protective mask when sanding gesso. When the first layer of gesso is dry, use the sanding pad to lightly smooth the surface until the entire board has the texture of an eggshell. Wipe the grit from the board with a lint-free paper towel. Repeat this application process for four coats of gesso.

Paint four coats of gesso on the back of the hardboard to keep it from bowing in the humidity. Don't worry about sanding it down on the side because you won't be painting on it. Be careful not to create any gesso buildup on the edge of the board while covering the back.

Optional Step for Preparing a Hardboard or Canvas

Since transparent glazing requires the white of the board or canvas to create highlights, it might also be helpful to apply a coat of Titanium White oil paint mixed with medium to the prepared gesso board. This is helpful in case you decide to touch up your finished painting with white paint. Since gesso is not a pure white, the paint layer will act as a tonal base for the oil glazes so that the touch-up paint matches the base color of the board.

To apply a layer of white paint, mix it with a bit of medium to a thick, creamy consistency. Use the gesso roller to apply it to the entire surface, and allow it to dry completely.

Digital Reference Photos

Many realism painters work from photos. Capturing an image via photography is a great help in reminding us what attracted our attention to the object in the first place.

Digital photography has greatly changed how artists work with photo references. For starters, you no longer have to wait until your film develops. Using a computer and simple photo software, you can view your photos on the large monitor while you are still in the process of shooting the references. This helps you to assess your vision and rearrange your setup in new and different ways. Simple photo software allows you to easily enlarge, crop, rotate and manipulate your images. Digital cameras offer numerous automatic light settings that help you manipulate the contrast and values of your compositions. Study your camera's manual to learn its features and dramatic light settings, such as manual white balance or ISO speed (light sensitivity). The camera shop that I purchased my equipment from even helped me learn the proper camera settings for photographing my work. They printed quality photos from my first few digital files to make sure the camera was capturing the paintings in perfect color. See page 22 for more information on photographing your art and setting up your composition.

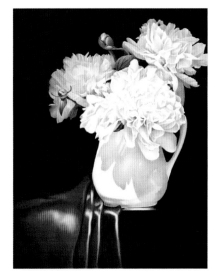

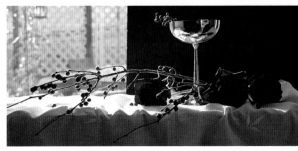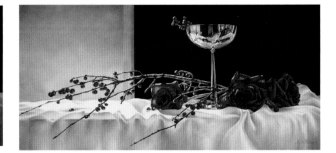

The Reference Photo vs. the Finished Painting

You don't have to paint everything that is shown in your photos. These digital shots are a few of the reference photos for the paintings throughout the book. The photo reference for *Red Satin and Peonies* shows a white cabinet that I replaced with a simple dark table in the painting (see page 133). In *Winter Berries* (see page 136), I simplified the view outside the window in the photo to a light gray value to keep the focus on the subject in the painting.

Take Photos at Eye-Level

When a still life is photographed from above with the subject below eye-level, you are describing the space in front of and behind the object. Taking reference photos of your composition at eye-level helps utilize lighting to greater effect and keeps the focus on the subject.

This reference photo for *Sweet Perfection* (see page 89) was taken at eye-level. It shows very little of the tabletop and creates a trail of light leading from the left light source, through the crystal bowl and out the other side. This accents the crystal bowl as the center of interest.

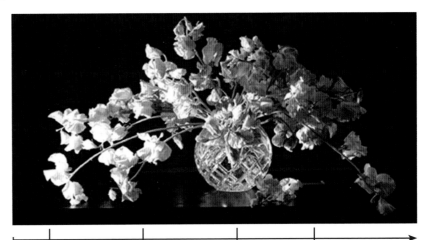

| trail of light begins | the eye follows the light | the crystal bowl's edges act as road map | fewer light areas slow the eye and keep the eye on the painting |

Simplify Your Backgrounds

Place a light, medium or dark gray mat board behind your object to simplify or eliminate the background. This can also be accomplished with draped fabric. Photographing a simple, dark background adds interest to the values of your object, and helps draw focus to the light patterns across the composition.

Photography Tips

* Look for light and dark value patterns while you are photographing. Squinting helps you see the contrast.

* Use sunlight for large light areas with a small dark area.

* Use a spotlight for large dark areas with a small light area.

* Make sure your eye can follow the pattern of light.

* Use only one type of light source such as a spotlight or sunlight through a window, so your camera (or more specifically, your camera's digital white balance) doesn't get confused.

Photographing Your Artwork

Digital photography has made photographing your own artwork easier. Use a high megapixel SLR camera (over ten MPs is best) with a polarizing filter placed on the lens. This helps reduce the shine produced by the oil paint. A lens won't solve all the glare problems, though; proper lighting is most important. When selecting a digital camera, make sure it has a grid option on the LCD screen. It helps square up the camera with the painting

There are many reasons you should photograph your finished artwork. Besides simply tracking your work over time, you might need to e-mail a photo of a finished painting to an interested buyer or send a JPG file to enter a juried art show. But beware, never adjust a digital art file so it looks good on the computer monitor. Monitors are not color accurate and vary from one to the next. What looks good on your monitor may not look good on an art judge's monitor. You're better off leaving it as is.

However, to publish your artwork in the highest quality, such as in a glossy magazine or a book, you need a combination of proper lighting, quality equipment, software and knowledge of correct camera settings. Like anything else, it takes a small investment of time and money to become proficient at digital photography. If you would rather not deal with it, you can always have your work photographed professionally.

Use a Polarizing Filter on Your Camera Lens and Lights to Eliminate Glare
The white square on the photography light photo is a polarizing filter. When you combine a lighting filter with a camera lens filter, all of the shine of the oil paint is eliminated. There is nothing worse than being rejected from a juried show because the juror can't see part of your painting hidden under the glare.

gray felt background gray bar strip power box for lights

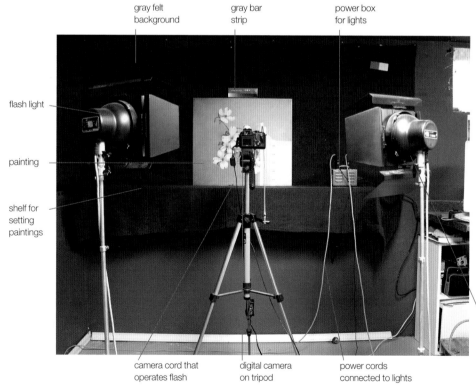

flash light

painting

shelf for setting paintings

camera cord that operates flash digital camera on tripod power cords connected to lights

flash light

Set Up a Room to Photograph Your Paintings
I photograph my artwork in my dark basement. I purchased a set of two photography lights that stand on tripods hooked up to a power box. They hook up to my camera by a shutter cable that fires the lights when I press the shutter release, so the only lights that illuminate the painting are the photography lights.

Varnishing a Painting

It is important to protect your paintings with varnish because transparent glaze layers are so delicate. Wait until your painting is totally dry to varnish. In most cases, that will take a few weeks. You can speed the drying time by using a small ceramic heater in an enclosed space. If your paint is really thick, it may take a couple of months to a year before your painting is dry enough to varnish. To test whether a painting is dry, take a small rag and a drop of medium or varnish and rub the surface of the artwork. If you pick up any paint on the rag, it's not dry.

Click Before You Varnish

Always photograph your finished painting *before* you varnish it to reduce glare.

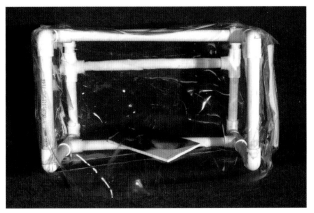

Build Your Own Varnish Booth

Design a varnishing booth to protect your studio from the odor of varnish. Construct the booth with plastic PVC piping available at a hardware store and strong vinyl sheeting from a fabric store.

You can make a varnishing booth any size you want; simply have the PVC tubes cut to size at the hardware store. Create a box using PVC corner fittings, wrap it in vinyl sheeting and cut out an opening flap that seals with Velcro.

Keep the vinyl sheeting closed when the booth is not in use to cut down on the dust particles that get inside. To use the booth, open the flap and place your finished painting inside. Spray three coats over a period of three days for the best coverage. Make sure to wear a mask and use an exhaust fan when spraying. After each application, close the booth and allow the painting to cure as needed. The booth keeps most of the odor inside and prevents dust from settling on the varnish as it dries.

Removing Varnish

Always use a varnish that can be removed or retouched in case a painting needs to be repaired or the varnish is damaged. The alkyds used in many of today's varnishes and mediums can be difficult to remove. If your painting is damaged, consider hiring a professional to remove and re-varnish.

If you choose to remove the varnish yourself, always wear rubber gloves. Lay down a heavy plastic trash bag and lots of newspaper to protect your working area and to soak up the varnish-removing chemical. I prefer Winsor & Newton Sansodor Low Odor.

Dip some cheesecloth in the varnish remover and rub the painting until the varnish loosens. This takes some patience, but keep dipping and rubbing until you see movement. Eventually you will feel and see the texture of the original painting surface as well as the duller oil paint. Once all the varnish has been removed, wipe the painting clean and let it dry for a few days. If you plan to retouch the painting, make sure it is fully dry before reapplying varnish.

An Introduction to Transparent Glazing

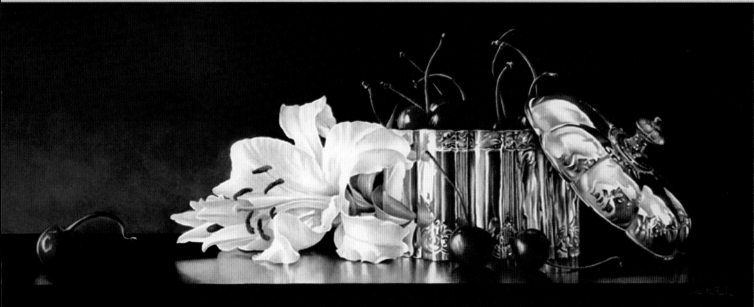

Summer Splendor ❧ 13" × 32" (33cm × 81cm)
Oil on hardboard ❧ Collection of the artist

ARTISTS THROUGHOUT HISTORY HAVE USED NEW
technology to help them create their artistic vision. It may be unique
varieties of lighting, or cameras or even computers that help them to cre-
ate their art. No matter what style and technique they use, it is the spark
of inspiration and one's inner creative vision that sets each artist apart.

In my paintings, I strive for luminous realism. Realism is portraying a
subject as accurate and detailed, though what details are accentuated can
vary. It could be depicting the fine details of every hair on one's head, or,
as we will do here, capturing realistic light. In this chapter, I will show
you the tools to achieve the luminosity of transparent glazing with a few
simple exercises. Try all of the techniques that interest you, and listen to
your inner voice to find what you enjoy most.

What Is Transparent Glazing?

Transparent glazing is the process of optical color mixing using transparent oils. *Color mixing* is the theory of combining colors to create other colors. With opaque oils, this is done by mixing the paints on your palette. With transparent oils, colors are layered, and since the layers are transparent, the viewer can see through them to the colors below.

In other words, the colors mix optically. How the eye sees transparent color is what makes transparent glazing so luminous. See page 32 for more on basic color theory with transparent glazes.

This quote from Johann Wolfgang von Goethe's manuscript *Theory of Colours* (1810) describes my love of transparent color: "The relationship of light to transparent color is forever attractive when losing oneself in its depth. The ignition of color and the blending in to each other, recurring and disappearing, is as breathtaking in great pauses from eternity to eternity, from the highest light to the lonely and eternal silence of the deepest tonalities."

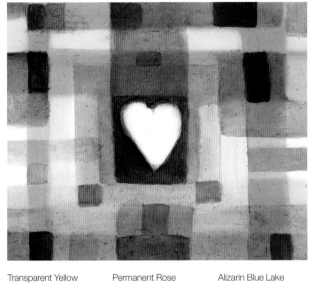

Transparent Yellow Permanent Rose Alizarin Blue Lake

Transparent Collage

How many colors do you see in this example? Using optical glazing, it was created with only three colors: Transparent Yellow, Permanent Rose and Alizarin Blue Lake. Experiment with a color abstract like this painting, one color at a time. Start by painting stripes of the three separate colors. When dry, alternate the other two colors to create a second layer to achieve new value glazes and colors. Make sure to let each glazed layer dry to maintain the luminosity. As you complete more layers, try to find new places to alternate and change the values. With each glaze layer, the color hues change and values become darker.

Five Keys to Optical Realism

1. Plan your painting. Take plenty of time to draw accurate shapes before you begin painting.

2. Use a full range of values to create realistic forms and lighting.

3. Balance your composition with light. The flow of light helps move the eye through the whole painting.

4. Create soft and hard edges. (See page 43 for more on edges.)

5. Strive for realistic color or color as we see it in nature. A yellow rose is not just yellow, but is made of many colors.

Here are some familiar terms regarding transparent glazing that will pop up throughout this book:

Glaze: A thin application of paint that dries completely before another is applied.

Transparent: The quality of allowing light to pass through so you can see through the object. Paint colors that you can see through are transparent. Many paint colors are transparent. White or black can be added to transparent colors to make them opaque.

Opaque: The opposite of transparent, allowing no light to pass through. It is also known as *body color*.

Luminosity: The quality of emitting light from within. A luminous object appears to give off a glow from under the surface, such as under a glaze on a painting.

Local color: The natural color of an object as it appears without added lighting or shadow. For instance, the local color of grass is green.

Optics: The physics dealing with light and vision. In art, the term optics describes how the eye perceives light through layers of color and how we translate such information into one final hue.

Focal point: The center of interest in a painting.

Paint What You Love
My heart fills with joy when I create beautiful images of flowers and objects.

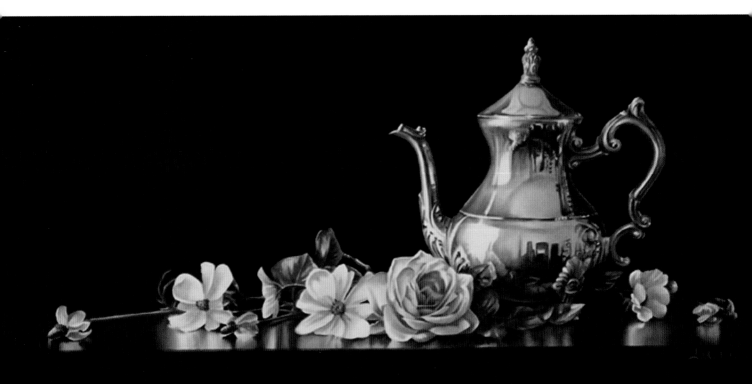

Afternoon Melody 🍂 11" × 23" (28cm × 58cm)
Oil on board 🍂 Collection of Kevin and Susan Verner

Composition With Light

Light plays a vital role in the overall viewer experience of a painting. The way light falls across a composition helps lead the viewer's eye to specific points in the painting, defined as the *focal point*. Experiment with many types of lighting to create various points of interest in your compositions. I photographed the subjects for the painting demos in this book using different lighting setups. Practice arranging objects in different light settings to get a feel for dramatic shadows and luminous glows.

Five Examples of Light

1. **North light:** The subjects of *Summer Comfort* (see page 88) were photographed sitting next to a north light window on a bright, sunny day. North light changes depending on the sky and has a soft range of values.

2. **Full sun:** The subjects of *Two Pears* (see page 40) were photographed outside in the early morning sunshine. This helped create long cast shadows to tie the pears to the table and deep background tones.

3. **Sunlight with backlighting:** The subjects of *Winter Berries* (see page 136) were photographed inside near a door so sunlight streamed through behind the still life. It highlighted the edges of the roses and berries, dropped the front of the tablecloth into shadow, and gave the feeling of snow in the white linen on the table.

4. **Artificial light:** The lighting of *Sweet Perfection* (see page 104) was arranged using a 100-watt spotlight on a tripod, and photographed using manual white balance. This helped the digital camera capture a dark setting with a dramatic trickle of light moving throughout the painting.

5. **Shade:** For *Sheer Reflections* (see page 116), the subjects were photographed on a sunny day under a tree so the light dappled over the sheer material. This made the shadows and folds of the material part of the subject instead of the background.

Balance Light and Dark in Your Compositions

Pay attention to how light flows across the objects in a composition. Connecting the light areas and dark areas in your painting helps tie elements together to create a cohesive image. In *Summer's Last Blush*, the petals of the roses weave abstract white shapes that link the flowers and the highlights in the brass. Similarly, the dark background blends into the leaves and stems, as well as the shadows on the brass container.

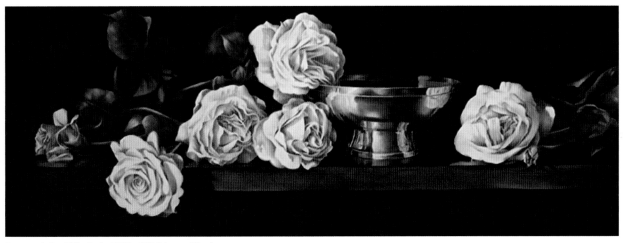

Summer's Last Blush ❧ 13½" × 35" (34cm × 89cm)
Oil on board

Transparent vs. Opaque

Blending transparent glazes is a delicate process. It is much more time-consuming than blending opaque colors, but it is a technique that helps achieve the glowing effect favored by so many Old Masters. When creating a still-life composition for transparent glazing, an opaque background can create a stunning contrast to your luminous subject.

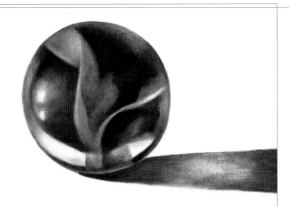

Transparent Blue Marble
To create the transparent glazes used in this marble, the colors were mixed with an oil painting medium and applied in a very thin layer. The result is more luminous than if using only opaque colors.

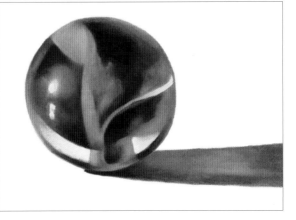

Opaque Blue Marble
Adding white or black to a pigment makes the color opaque. Note the flat tint of the marble's shadow compared to the light, reflective tone of the transparent marble.

Adding Opaque Touches

Transparent glazes recede and opaque colors move forward. Decide where you want your viewers to look before you add any opaque touches to your painting. The opaque paint will draw in the eye.

A B

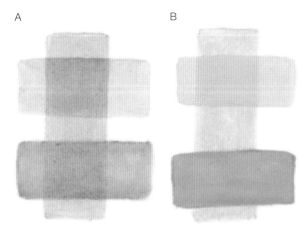

What the Eye Sees
Transparent glazing only works with transparent colors. What makes this painting style unique is that each individual color is added one glaze at a time. This technique allows the viewer's eye to see through each layer of color. Illustration A shows a transparent pink and yellow glaze over a transparent blue glaze, which allows the eye to see purple and green. Illustration B shows an opaque pink and yellow over an opaque blue, which allows the eye to see only pink and yellow. How the eye views transparent color is what makes transparent glazing look so luminous.

Transparent Colors

The transparent colors shown on this page are the standard palette I use for glazing. They are based on the primary colors. You don't need to use all of these colors in one painting. Colors may not have the same names from manufacturer to manufacturer, just as they may not have the same transparent properties. Make use of the color chart for each company, so you know what you're working with.

When selecting colors for your palette, it is important to know if you are using transparent colors or stains. The paint tube or label will distinguish them. You should also have an idea of the scheme of colors you wish to use. Decide if you want your painting to have a warm or cool feel. If cool, you might add a green, a purple and an earth tone. If warm, perhaps a red, a yellow and an orange or brown. When arranging your palette, place your opaque colors in a separate location so you don't get them confused with your transparents.

Be Careful Mixing "Special" Colors

Many manufacturers sell special mixtures of colors unique to their brands. Mixing special tube colors with other special colors can make mud, so you have to be careful. For example, Grumbacher's Perylene Maroon is a premixed purple hue, and Greenish Umber is a brownish green. They are each a combination of several specialty colors. You can use them by themselves instead of mixing the color yourself, but you have much more control when working with a limited palette of primaries and secondaries.

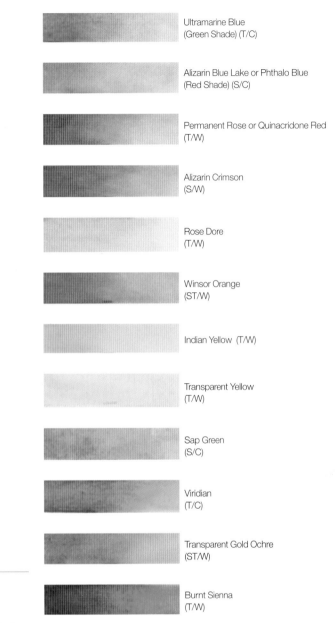

Ultramarine Blue
(Green Shade) (T/C)

Alizarin Blue Lake or Phthalo Blue
(Red Shade) (S/C)

Permanent Rose or Quinacridone Red
(T/W)

Alizarin Crimson
(S/W)

Rose Dore
(T/W)

Winsor Orange
(ST/W)

Indian Yellow (T/W)

Transparent Yellow
(T/W)

Sap Green
(S/C)

Viridian
(T/C)

Transparent Gold Ochre
(ST/W)

Burnt Sienna
(T/W)

My Palette

These codes provide a guide for my standard palette that's based on the primary colors. Make sure you read the labels and lids of all paint tubes carefully to know if a color is transparent, semitransparent or opaque.

T—transparent
S—stain that builds deeper values
ST—semitransparent
W—warm
C—cool

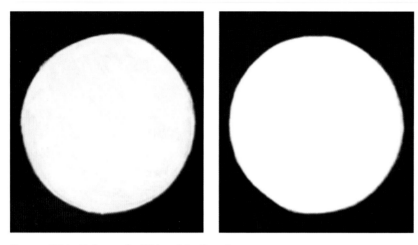

Opaque White Paint vs. the White of the Board

The main reason glazing results are so luminous is that colors are glazed on the white of the board or canvas, instead of simply using white paint on top of color. In this example, the white circle on the left was painted on a dry blue background. The white is a bit cooler-looking and doesn't look as bright or pure. In the circle on the right, dark blue was painted around the white background of the board, creating strong contrasts and a clean, white circle. With transparent glazing any hue showing through a color influences how the eye views the final glaze of color, even using opaque white.

The Order the Eye Perceives Color

The eye first sees yellow, then orange, then red, followed by blues and violets. This means yellow-green is registered before blue-green, and so on. Using a yellow or orange glaze as your focal point will attract more attention over a blue or violet focal point.

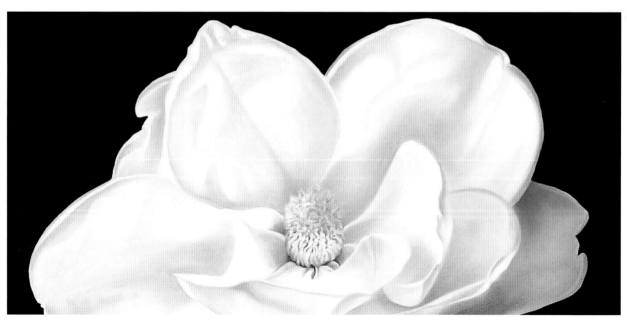

Using an Opaque Glaze

Touch up your art with opaque colors for sharp, clean edges. In *Time Suspended* (see page 140) I used a milky white glaze on the magnolia. Sometimes, adding a very thin white glaze mixed with a touch of color is a good way to build thin glazes without having to use a lot of medium. When glazes are thinned out with too much medium, they can attract and show dust. Since you must use a lot of medium to thin out color glazes on a white object, a milky white glaze can be a good alternative to create a pale value.

Every time you paint a glaze you should be thinking about value—how light or dark the color is—and how each glaze will enhance the object's form. Stop each glaze as soon as the previous glaze peeks through. Strong value changes happen naturally this way.

The Benefit of Light Value Glazes
Working with a thin value glaze allows you to build different colors more gradually and achieve more luminosity. The example on the left is too dark, making it harder to blend out to white board in a short space. The example on the right is much better value for a single glaze. Avoid loading your brush with too much paint to help you achieve lighter glazes.

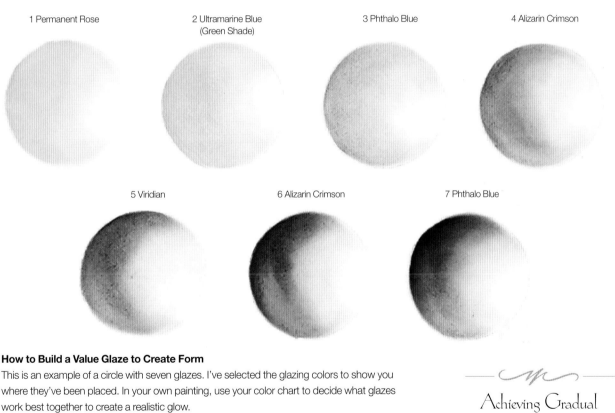

1 Permanent Rose

2 Ultramarine Blue (Green Shade)

3 Phthalo Blue

4 Alizarin Crimson

5 Viridian

6 Alizarin Crimson

7 Phthalo Blue

How to Build a Value Glaze to Create Form
This is an example of a circle with seven glazes. I've selected the glazing colors to show you where they've been placed. In your own painting, use your color chart to decide what glazes work best together to create a realistic glow.

1. Glaze 1, using Permanent Rose, covers all of the circle except for the white highlight. Blend the paint as it nears the highlight to create dimension.

2. Glaze 2, using Ultramarine Blue, covers only two-thirds of the Permanent Rose glaze. Leave a bit of pink showing to represent the lightest value next to the white highlight and add a shimmer to the circle.

3. Glazes 3 through 7 each cover less area than the previous glaze. Allow each glaze to fully dry to create a luminous effect.

Achieving Gradual Value Shifts

Use light transparent colors in your first glazes, and staining colors in your final glazes. This will help you achieve a gradual value shift from light to dark.

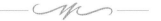

Color Basics for Transparent Glazing

When you work with transparent glazing you need only a limited palette of primary colors and a few others. Try this exercise with different sets of primaries, and also experiment with secondaries and luminous grays. If you did this exercise every day, think of the color chart of glazes you'd have to refer to when painting.

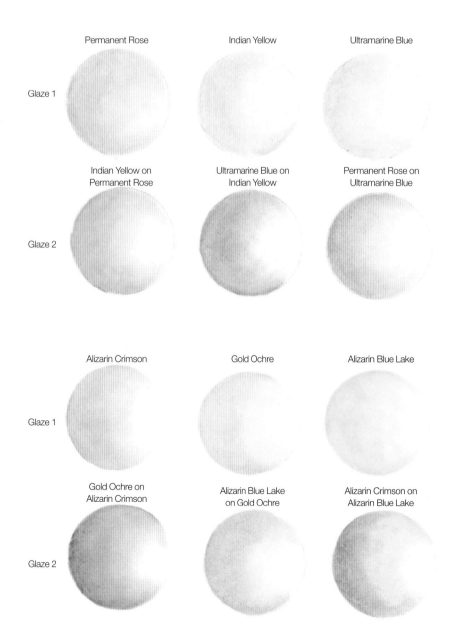

Glazing With Transparent Primaries: Example 1

For the first glaze, select a transparent color from each primary group: Permanent Rose, Indian Yellow and Ultramarine Blue. Lightly glaze a circle, leaving a white highlight. Let it dry.

For the second glaze, paint a different primary over each circle: yellow on red, blue on yellow and red on blue. You've created secondary colors without any mixing! This is color optics at work.

Glazing With Staining Primaries: Example 2

Start with a glaze of three primaries. Paint the second glaze with a different set of colors to see what happens. Here, the three staining colors are Alizarin Crimson, Alizarin Blue Lake and Gold Ochre (yellow on red, blue on yellow, and red on blue). By using staining primaries, we've created darker hues of orange, green and purple than we did using transparent colors.

Optical Grays

Not every object will have solid areas of bright glazes of color. *Optical grays* are luminous areas of transition from highlight to color that happen naturally while glazing with primaries. Create a gray by painting a glaze of each primary color one at a time. The area where the colors overlap is the gray. The glazes must be very thin to achieve a luminous glow that ties the color and highlight together. Study the grays that popped up on the rose on page 125.

Optical Options
You can glaze many different grays by switching the order that you apply each primary glaze. When you mix the three primary colors together, the result is a dull gray such as the dark circle in the lower right of the example. Transparent glazing of one primary color after another results in a group that is much more luminous.

Optical Grays Exercise
The difference in the three grays below is the order of the glazes. The color balance is delicate and subtle. The third color glaze determines the overall hue of the gray. Experiment painting grays in the three different orders illustrated below. The challenge of optical grays is to keep the three colors close in value. Note that the blue hue is deeper in value because it is made up of two transparent stains.

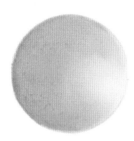

Optical Gray: Pink Hue
Glaze 1: Ultramarine Blue
Glaze 2: Indian Yellow
Glaze 3: Permanent Rose

Optical Gray: Yellow Hue
Glaze 1: Permanent Rose
Glaze 2: Ultramarine Blue
Glaze 3: Indian Yellow

Optical Gray: Blue Hue
Glaze 1: Gold Ochre
Glaze 2: Alizarin Crimson
Glaze 3: Alizarin Blue Lake

The Glazing Viewer

A few years ago, I developed a glazing viewer to help my students visualize the next glaze. It can be used with any transparent medium—oils, watercolor or fluid acrylics. Simply lay the viewer on top of a glaze and look through the viewing window to get an idea of the result of different colors.

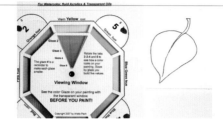

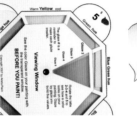

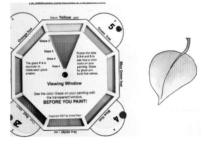

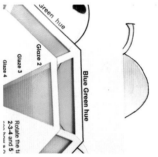

1 Place all the tabs in their main positions and rotate the window to the yellow glaze. Lay the viewer on the leaf to decide how light or dark you want your value to be. The viewer shows five shades.

2 Here's the leaf with one yellow glaze. Let dry before using the glazing viewer to decide on your next glaze.

3 To create a green tint, lay the blue window over the yellow painted leaf. This is the essence of the glazing viewer. Play around with it to get an idea of how other glazes might look on the yellow before you commit to painting the next glaze.

4 Here's the leaf after a glaze of blue has been painted over the yellow.

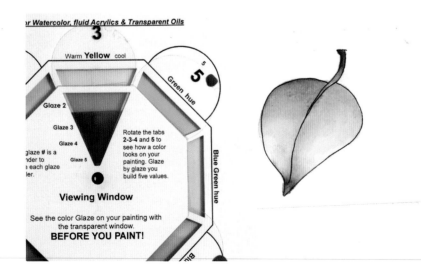

Layer the Tabs to Plan Ahead

What would a red glaze look like on top of the blue and yellow? Simply turn multiple tabs to find out. You can view up to five glazing layers at a time using the viewer. Mix and match to get a clear idea of how you want to proceed.

Background Techniques

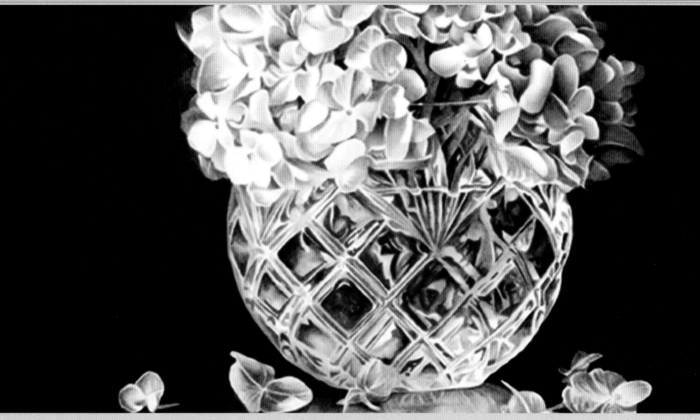

Hydrangea Sprinkles ❧ 12" ×15" (30cm × 38cm)
Oil on board ❧ Collection of Pam and Ken Walsh

WHEN A COMPOSITION'S SUBJECT IS MORE COMPLEX, THE BACKGROUND can sometimes be the only place for the eye to rest. It is challenging to select proper values for a subject's background. Many artists simply leave the background blank until the subject is complete. This can be tricky and complicated, though, because often the final background color or value doesn't quite fit with the finished subject.

In my own work, I prefer simple backgrounds to complement the detailed subjects. I begin the background before glazing the main subject by painting around the white of the canvas where the subject will be placed. In *Hydrangea Sprinkles*, the dark purple area around the blossoms' edges adds interest to the deep, blue-black background by helping the soft edges drop into the right side of the background.

In this chapter, we'll learn how to plan and choose strong background values, and discuss helpful background techniques that lead to realistic, fluid compositions.

A neutral color chart is a great tool for selecting background colors. A neutral background helps tie the background and subject together while helping each aspect of the composition retain an individual look. One way to create these neutral mixtures is by combining two of the main glazes found in your composition's subject. Mixing transparent background colors creates depth behind the subject, while opaque backgrounds help move the subject forward.

Below is the color chart I use in my studio. I refer to it often when choosing my background combinations. When creating your own color chart, use the colors from your standard palette. Don't worry about adhering too closely to my choices; everyone's palette is different. Have fun with it!

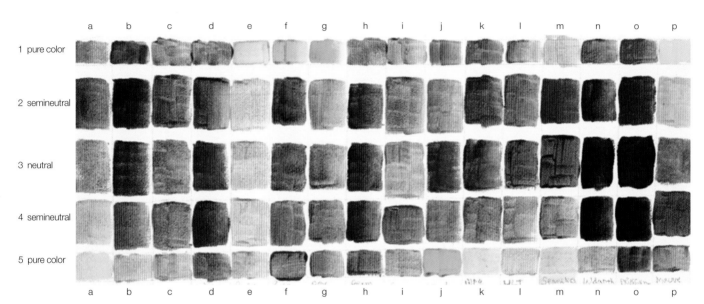

	a	b	c	d	e	f	g	h	i	j	k	l	m	n	o	p
1 pure color																
2 semineutral																
3 neutral																
4 semineutral																
5 pure color																

Create a Neutral Color Chart

Select colors from your standard palette to create your neutral color chart. Mix and match to create as many new combinations as possible.

1 Use a pencil to divide a piece of scrap board into five rows. Paint a row of squares of your favorite colors along the top (1).

2 Reverse and mix up the colors along the bottom row (5). Each color should correspond opposite a color on the top row.

3 Mix the middle, neutral row (3) by combining the two colors opposite each other in the top and bottom rows. Mix with equal parts.

4 Create semineutral rows by combining the two opposite pure colors two parts to one. Mix row 2 with two parts of the top row color, and row 4 with two parts of the bottom row color. This will create two semineutral tones with varying dominant shades.

Top Row		Bottom Row	
a	Ultramarine Blue (Green Shade)	a	Transparent Yellow
b	Prussian Blue	b	Winsor Orange
c	Mauve (Blue Shade)	c	Transparent Gold Ochre
d	Sap Green	d	Winsor Red Deep
e	Magnesium Blue	e	Rose Dore
f	Alizarin Blue Lake	f	Rose Madder Genuine
g	Indanthrene Blue	g	Permanent Rose
h	Viridian	h	Alizarin Crimson
i	Mauve (Blue Shade)	i	Sap Green
j	Winsor Orange	j	Viridian
k	Rose Madder Genuine	k	Magnesium Blue
l	Permanent Rose	l	Ultramarine Blue (Green Shade)
m	Transparent Gold Ochre	m	Alizarin Blue Lake
n	Alizarin Crimson	n	Indanthrene Blue
o	Winsor Red Deep	o	Prussian Blue
p	Transparent Yellow	p	Mauve (Blue Shade)

Testing Different Background Hues

When painting from reference photos, the backgrounds often strongly influence our color choices. When planning your composition, it is important to ask yourself how the background color will add interest to the painting.

This simple background exercise will help you figure out the proper background colors and values before you begin painting.

First, print out your reference photo in a large size such as 8" × 10" (20cm × 25cm) and cut out the main subjects with scissors. For the *Two Pears* demo below, I cut out the white table and the fruit. Lay out a few pieces of primed mat board (scraps work fine) about the same size as your reference. Paint a different background value over each board and lay the photo cutouts on these background examples. Being able to see how the different backgrounds work with your subjects will help you feel confident about your background color choice.

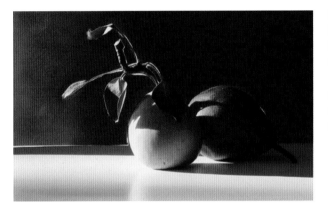

Red Background Test

Mix a dull neutral red color with Alizarin Crimson and Sap Green. Thin it with medium to get the lighter value for blending the left side into the right.

What happens? The red background complements the green pear nicely, but it is too similar to the red pear to create enough contrast. The cool white table also conflicts with the red background choice.

Black Background Test

Mix a dark black mixture with equal parts Alizarin Crimson, Sap Green and Phthalo Blue. Keep in mind that you can easily adjust the dominant tone of the black mixture by using more red, green or blue.

What happens? Though the black background is full of drama and contrast, and helps the eye stay on the subject, there is no value movement and too strong a contrast with the white table.

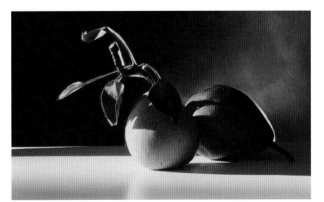

Blue-Black Background Test

Use the black mixture from above and add a bit of Phthalo Blue for the left side of the background. Blend it with a lighter color—pure Alizarin Blue Lake—to achieve a value change from left to right.

What happens? The dark value on the left of the two-tone background contrasts well with the green pear's stem highlights. There is also a pleasing visual contrast between the lighter blue background on the right and the cool purples of the red pear, as well as its dark shadowy side. The light blue works with the blue cast shadows on the table. This is the best choice for the *Two Pears* demo on page 44.

The Initial Background Application

In transparent glazing, backgrounds and edges need special attention because the subjects start out white. Soft edges (see page 43) help a subject's darker edges melt into the background. Avoid rough edges because they are difficult to hide and can contribute to your subject looking cut out and pasted on.

1 Apply the Background Paint
Use a filbert brush to apply the paint with a crisscross pattern covering a large area. The size of your background brush depends on the size of your canvas. The brush should be big enough that you do not struggle to cover an area, probably between a no. 4 and a no. 20. Be sure the brush is loaded with plenty of paint to get full coverage.

2 Smooth Out the Background
Use the same brush from step 1 and pull the paint horizontally with a delicate touch. This smooths the background paint and creates a transition into a lighter value area.

3 Blend the Background
Use a soft mop to blend the value change. The size of the brush will vary on the size of the area you are blending, probably between a ⅛-inch (3mm) and a 1-inch (25mm). Value changes in backgrounds help to create movement between your subject and background.

Stippling the Background

There are many ways to paint backgrounds, but I prefer stippling when painting on hard surfaces like a gesso board. *Stippling* is the act of pouncing the brush up and down on the surface to create a pattern of similar marks. Hold the brush vertical when stippling; it is more of a blending technique than a painting technique.

There are two main reasons to stipple the background. With dark backgrounds, streaks often show through the white board or canvas no matter how much you try to blend. Stippling helps create a consistent texture that you can then smooth out with a blending brush. Stippling is also a good way to lighten a value.

Stippling
With a transparent background it is hard to hide streaks, so stippling helps solve this problem. This is an example of stippling with a ½-inch (12mm) synthetic mop.

Use Blending and Stippling for Light Backgrounds
Blending and stippling work well for the soft edges required in light-colored backgrounds. The background for *Springtime Memories* was applied in two layers. The first layer was a pink-lavender mixture of Permanent Rose, Ultramarine Blue and a touch of Burnt Sienna stippled over the entire background. Before the stippled layer dried, I used a 1-inch (25mm) mop to blend and smooth the paint as shown in step 2 on page 38. After it dried overnight, I stippled a lighter value of Ultramarine Blue over the composition's left side, then blended as before.

Springtime Memories 🐦 27" × 23" (69cm × 58cm)
Oil on board 🐦 Collection of the artist

The Foundation of Transparent Glazing

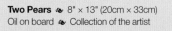

Two Pears ✒ 8" × 13" (20cm × 33cm)
Oil on board ✒ Collection of the artist

THIS CHAPTER ILLUSTRATES A DETAILED DEMONSTRATION, *Two Pears*, from start to finish. Think of it as the foundation of glazing instruction in this book and use it as a reference as you continue to learn. *Two Pears* walks you through each glaze one by one, outlining the basic techniques of transparent glazing. Throughout the demo, work on training your eyes to see the individual primary colors that make up each object. By layering blue, red and yellow instead of mixing, you will achieve the most luminous results.

As we've discussed, in transparent glazing, each glaze affects the previous glazes as well as the glazes that follow. You might find in painting the green pear that applying a blue glaze over the yellow creates a nice blue-green. Reverse the glazing order and paint blue over yellow to create a yellow-green. Review the basic color theory for transparent glazing on page 32 before getting started.

Transferring Your Drawing

Drawing your subject directly on a prepared board or canvas can be intimidating. Take time to study your reference photo before you begin drawing. Once your idea has taken form and you have a photo that is crying out to be painted, work out your drawing on tracing paper. Don't worry about drawing details at first. If your shapes, values and shadows are noted in your drawing, the details will come naturally during the painting process.

Reference Photo Study: *Two Pears*

Study your reference photo and note each of the cast shadows, highlights, value changes and types of edges. It's just as important to capture these parts of a scene as it is to have accurate shapes.

cast shadow (hard edge)

value changes (soft edge)

combination hard and soft edge

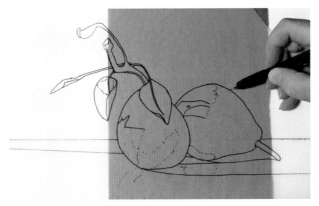

Transferring a Drawing

Transferring a drawing is an easy way to get accurate shapes. First, enlarge your reference photo to the size you would like to paint. Then trace the objects on tracing paper. Place a sheet of transfer paper under the tracing paper on a prepared board or canvas. Draw over the top of the tracing paper lines with a mechanical pencil or fine point marker. Use a pencil with colored lead to help you see where you have traced the pattern.

Tips for Transferring Your Drawing

- You want transfer lines and pastel pencil lines to dissolve after the first few glazes, so use a very light touch when transferring your drawing.

- Some brands of transfer paper do not dissolve in oil paint. I prefer Loew Cornell.

- Use a kneaded eraser to remove dark transfer paper lines before painting.

Drawing Directly on the Canvas or Board

A light gray hard pastel pencil works great to sketch your forms on canvas or board. It's dark enough to see, but light enough to dissolve in the first layers of oil glazes. Once the drawing is complete, remove any excess pastel by lightly blotting the board with a paper towel.

Preparing a Background for Transparent Glazing

Before beginning the background preparation for the *Two Pears* demonstration on page 44, study the reference photo on that page. When painting a background with transparent darks, make sure you like the strong contrast of the pears before you begin. Note the different types of edges, soft and hard, that take place on the two pears.

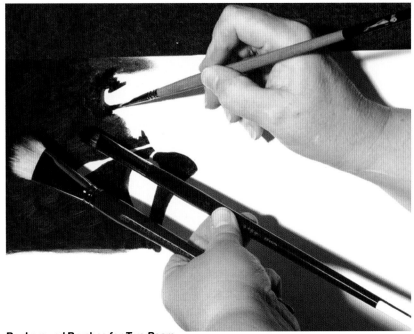

Background Brushes for *Two Pears*
We'll use three different brushes to apply the blue, two-tone background selected from the exercise on page 37: a no. 2 filbert brought to a point works great in corners or crevices, a no. 8 to no. 14 flat or filbert for applying paint in larger areas, and a ¼-inch to ½-inch (6cm to 12mm) mop to stipple and blend out the paint. Reload paint with a variety of brushes as needed. Your brush is too small if you have difficulty covering an area evenly; it's too big if you can't get near a shape's edge.

Stippling the Background in *Two Pears*
Stipple the deep blue background with a couple of small mop brushes, sizes ¼-inch (6mm) to ½-inch (12mm), to create an even texture.

Hard vs. Soft Edges in Two Pears

Hard edges are sharp and clearly defined. They can be found in areas with high contrast such as a highlighted object against a background. *Soft edges* are painted softly, perhaps blended, so they fade into the background. Study your reference photos' edges. You will need to scrub soft edges when the paint is still wet, so it helps to plan ahead.

Scrub and Blend In Soft Edges on the Shadows
With transparent backgrounds, leaving all hard edges looks unnatural. After you block in the main background color, look for shadowed edges to soften. While the background is still wet, use a scrubber or stiff brush to scrub the hard shadowed edges.

Use a ¼-inch (6mm) mop brush to blend over the scrubbed edges so that the subject's glazes, especially the shadowed sides, melt into the background.

Clean Up the Edges
It's OK to use Titanium White to fix mistakes that happen during painting, such as your brush hairs hitting the subject area. Before you begin your first subject glaze, take the time to clean up the edges of your subject using white paint. Allow this to dry before moving on. This is an easy solution to avoiding rough background edges and speckles showing through your transparent glazes.

Finished *Two Pears* Background and Edges
Study your hard and soft edges. Do you need to make adjustments? Allow the background to dry completely. You're ready to move on to glazing *Two Pears* with a luminous glow.

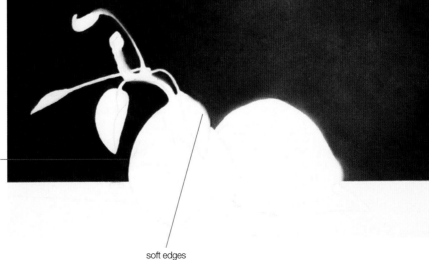

hard edges

soft edges

Transparent Glazing Techniques

The *Two Pears* demonstration is the foundation of transparent glazing instruction for the book. The large, simple subjects will help you get a feel for blending glazes to build values and create form. When you learn a new painting technique, it's best to paint large objects with a strong light source. The distinct shadows and highlight patterns will help you learn how to move and blend paint as you build your glazes.

Materials list

colors
Alizarin Blue Lake

Alizarin Crimson

Indian Yellow

Permanent Rose

Sap Green

Transparent Yellow

brushes
various sizes of filberts, mops and scrubbers (see page 11)

medium
select a medium that works well with your brand and type of oil paint (see chart on page 15)

tools
tracing paper

pencil

palette knife

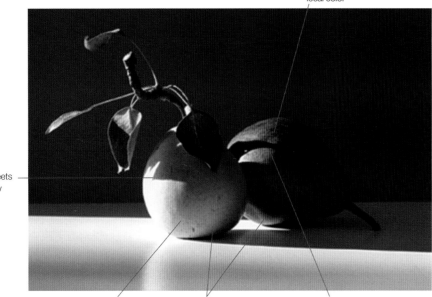

local color

light meets shadow

local color

value shift created soft edge: pink undertone on red pear and yellow undertone on green pear

transition from hard to soft edge

The Reference Photo
Think of the first glaze as the blocking-in stage. It is the most important glaze for establishing the local color and the white highlights of your object. When you study your reference photo, look for the lightest color of each object rather than the colors in highlight or in shadow. Look for the local color and decide which primary color family it fits in—red, yellow or blue.

1 Glaze 1: Starting With Local Color

Blocking in the first glazes of color is one of my favorite parts of the transparent glazing process. The first layers of color create the foundation for the finished painting, so take your time.

For the first glaze, start with the local colors of your subject. From studying the reference photo, it appears that the green pear has a slight yellow undertone, more so than blue. For the green pear, dress your brush in glazing medium and mix it into the Transparent Yellow. Remember, if you can see the paint accumulated on your brush, it's too heavy for applying a glaze. Before switching colors, wipe the brush on a paper towel, making sure it stays lint-free. Using the brush, block in the red pear with Permanent Rose. This first glaze should give the pears a round form indicating the left-side light source.

Wipe your brush, dip it in medium and paint a warm glaze of Sap Green for the leaves. Through the process of glazing, the stem will eventually appear brown. You could easily mix red and green together to make a brown, but glazing separately with the two colors will create a luminous variety of color.

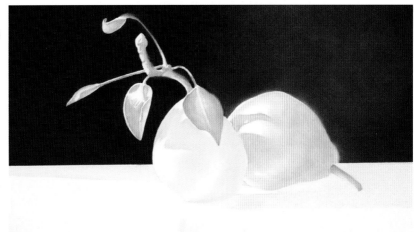

The blending of the first glaze should create a range of values that suggest a sense of light and form. Keep in mind that we are going to glaze darker values in later steps. Allow glaze 1 to dry overnight.

Blend for Soft Edges and Light Edges

Edges are most important in this first glaze. They must be applied thinly so you can vary your edges and values. The deepest values and hardest edges are going to be where you first apply the paint and where you see cast shadows. Softer edges and lighter values are the result of blending. Blending also helps create roundness.

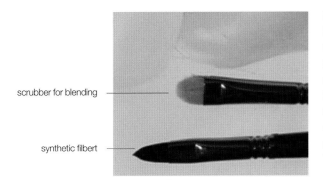

scrubber for blending

synthetic filbert

Early Glaze Brushes

Experiment with different types of brushes. Picking the correct brush to apply glazes is very important. Too stiff a brush may cause streaks, too soft and you may not pick up enough paint. A synthetic filbert works nicely for blocking in most of the pigment in the first glaze. A soft filbert such as mongoose is good for blending the values and edges of the glaze. It's just stiff enough to move the glaze around to create light values. Scrubbers also work great. Their hairs don't break and leave pieces in your glazes.

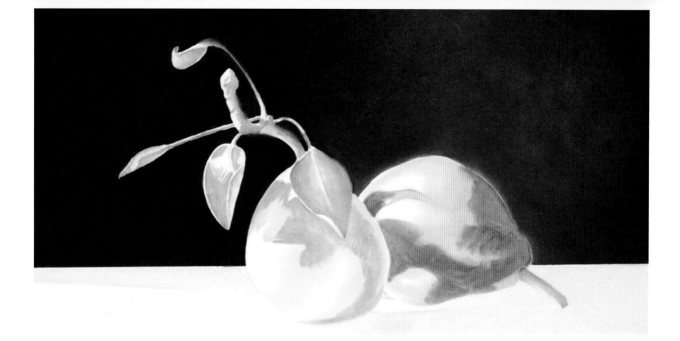

2 Glaze 2: Glazing Blue Over Yellow to Make Green

Paint a glaze of Alizarin Blue Lake over the dark yellow forms on the left pear. It is important to start the second glaze where the values are deepest, in this case, the most blue. The blue glaze should not fully cover the yellow. Leave plenty of yellow around the highlights to give you a warm value change in the glaze.

Study the value pattern of the red pear before you begin its second glaze of Permanent Rose. The two dark areas should be blended toward the lighter area in the middle of the pear. Apply the glaze as such.

Glaze Permanent Rose on top of the green of the stems to create a brownish hue. Use Alizarin Blue Lake on the leaves in the shadow areas to cool down the Sap Green, but allow some of the green to remain to give the shadows a nice value transition and green glow.

Paint a glaze of Alizarin Blue Lake to create the shadow on the table under the pears. Let it dry overnight. As your glazes develop into the next steps, use Alizarin Crimson and Sap Green to create the table's cast shadows. Keep in mind, if you mixed these three colors to paint the table, you'd get a muddy gray. By keeping them separate, you will end up with luminous cast shadows.

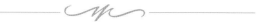

Choosing Colors for Glaze 2

Do you have to paint the same color in the second glaze? No! There are no rules with glazing—except to let the previous glaze dry completely. Try another yellow glaze, or switch to a blue glaze. Or take a left turn here and paint a pink glaze over the yellow to create an orange pear. If you're not sure what direction to go, study your reference photo or consult your color charts (see pages 29 and 36).

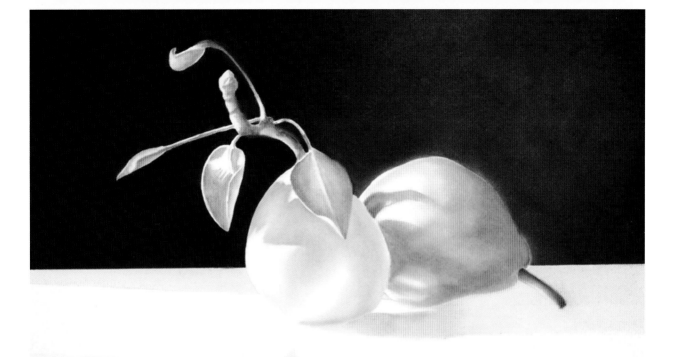

Blended Second Glaze

When using intense tube colors such as Alizarin Blue Lake, it is important to add enough glazing medium to make sure the glaze is light enough. I got a little carried away with the value of this second blue glaze and the pear looks a bit more blue than I'd hoped. To fix this, glaze Indian Yellow over the top once the blue is dry to create an optical yellow-green.

Let it Dry!

Always, always, always let each glaze dry at least overnight. In the morning, touch the painting to be sure it's dry before beginning another glaze.

shadow areas

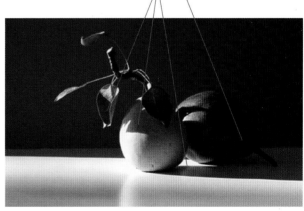

Add Interest With Shadows

Shadows are a great way to add interest to any subject. They add dimension to your painting and contrast with the highlights. A shadow can also show the time of day depending on its length. Shadows are full of color and value changes, so glaze them the same way you would your subject.

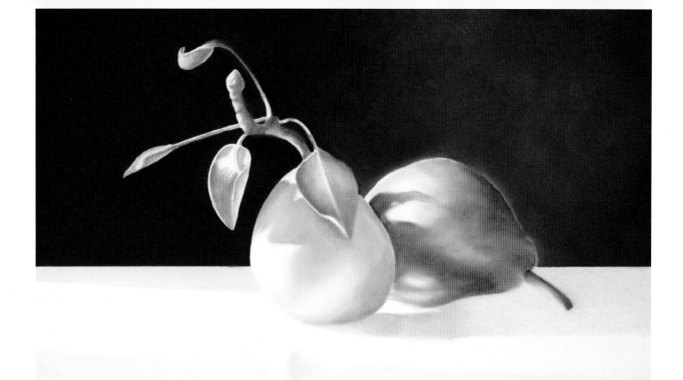

3 Glaze 3: Creating Reflections of Color

While the first two glazes built up the form, edges and cast shadows, the successive glazes are for building value, adding complementary colors and cool or warm tones. In the third glaze, we will create a reflected glaze of Alizarin Crimson on the green pear and a deeper value of Alizarin Crimson on the red pear.

Alizarin Crimson will deepen the value and create the cool shadow of the red pear. Reflect a bit of the red onto the green pear with a small glaze of Alizarin Crimson. Blend the edges if needed.

Begin the stem's wood color with a glaze of Alizarin Blue Lake. The green leaves need to be duller to help them stand out from the pear, so use the complementary Alizarin Crimson to darken the shadows. The color will get even deeper when the Sap Green glaze is layered on top of this red glaze in the next step.

Refer to your reference photo as your painting develops to figure out what colors to adjust in later glazes. Let it dry overnight.

Use a Medium to Thin a Glaze

There is no rule that says you must always use a medium in a glaze; this is a choice you make when painting. Use it to thin paint and create a light value, or to help a glaze dry faster. I prefer to work medium into the brush before picking up paint, but this is not mandatory.

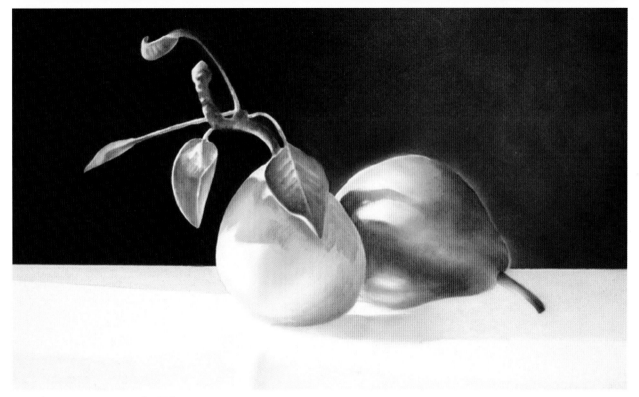

4 Glaze 4: Deepening the Values

The first three value glazes were very light, but this fourth glaze will start to deepen the values. The buildup of pigment is starting to show. Apply Alizarin Blue Lake to the areas that need shadow. Leave plenty of room to blend and allow the original glaze colors to remain in view.

Leave the previous glaze of the veins showing and apply a Sap Green glaze in negative shapes on the leaves to highlight the veins. Apply Sap Green evenly, but not so much as to cover the previous glazes. Let dry overnight.

Blended Fourth Glaze
Be careful, it's easy to fill in a subject's shapes with each glaze. Always leave some of the previous glaze showing to build form (see exercise on building a sphere on page 31).

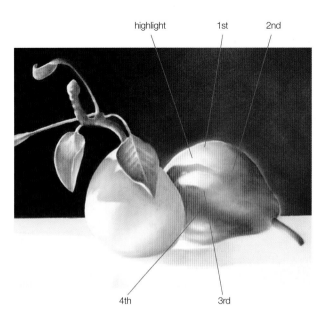

highlight 1st 2nd

4th 3rd

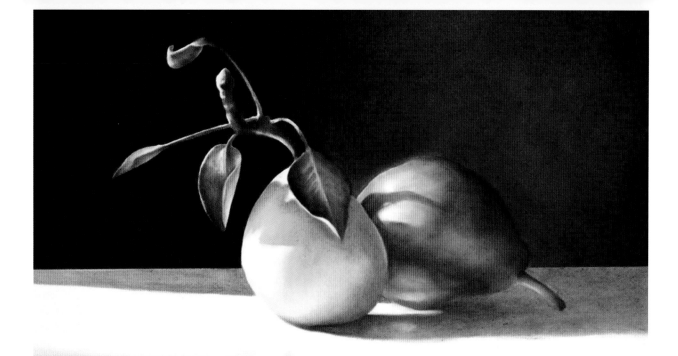

5 Glaze 5: Developing the Pear

By now the pears are starting to take on a more realistic look. For the fifth glaze, alternate Indian Yellow to deepen the lighter values, and Alizarin Blue Lake to deepen the shadows of the green pear. For the red pear, alternate Alizarin Crimson or Alizarin Blue Lake. It's OK if your painting develops differently than mine. If you see a value difference that you aren't comfortable with, simply adjust one color or another. Always take time to stop and look before glazing.

Since the Indian Yellow glaze has warmed the green pear, it may look nice to place this same yellow on the red pear to add color harmony. Make sure to keep this yellow glaze in the lightest areas of the pear. Otherwise, you could warm up the cast shadows on the table too much, and they need more red and blue glazes to retain a purplish hue.

Use some Indian Yellow on the other light objects. Adding it to the leaves will warm the sunny areas of the green pear. Add another glaze of Alizarin Crimson over the Sap Green on the stems. Let it dry overnight.

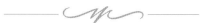

Avoid Wet=Into=Wet

Never apply new glaze if your previous glaze is not completely dry. This will destroy the shimmer of the individual colors. Remember, go slow and let dry for the glow.

Plan the Order of Your Glazes

When you plan your glazes, be aware of how the previous glaze will affect the next. Even repeating the local color glaze (the first glaze) on top of a glazed shadow color or a glazed reflected color might turn the glaze the wrong hue. For instance, to create a purple over a yellow glaze, you need to first add a red glaze before applying the blue, otherwise the blue over yellow will create a green. The last two color glazes will have the greatest effect on a subject's hue.

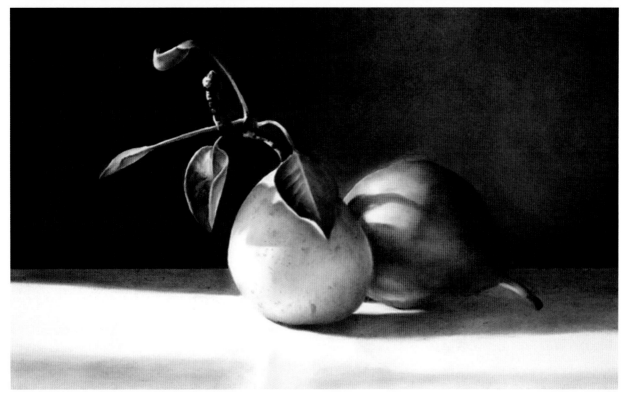

6 Glaze 6: Mixing Colors for Details

For the sixth glaze, the back edge of the red pear needs to be an even darker value than the background to lose its edge. In the final stages, such as this glaze, it is OK to mix transparent colors to create final values or details. Make sure to stay with the colors already used in the painting. Create a deep transparent purple mixture from Alizarin Crimson, Alizarin Blue Lake and a tiny touch of Sap Green, and blend toward the red area. Also use this mixture on the woody stem to create details of lines and dots.

The green pear needs some stronger values, especially near the cast shadow on the table. Create a deep blue-purple mixture of Alizarin Blue Lake with a touch of Alizarin Crimson. You don't need to add any Sap Green because the green hue has been created by the first yellow and blue glazes.

Now comes the fun part: details. Dab spots on the green pears with a pointed no. 1 filbert and an orange mixture of Indian Yellow and Alizarin Crimson. Dab on some Sap Green spots to add variety. So the dots don't appear too hard-edged, drag a small filbert or mop lightly over their edges. Create dots on the red pear in the same way using Alizarin Blue Lake. Let it dry overnight.

The reason we create the spot details at this stage when we still have one glaze to go is so they will look more naturally a part of the pears instead of pasted on at the last minute.

Achieve Natural Details

Always create the small details during the second-to-last glaze. This will ensure a natural look so they don't look like last-second additions.

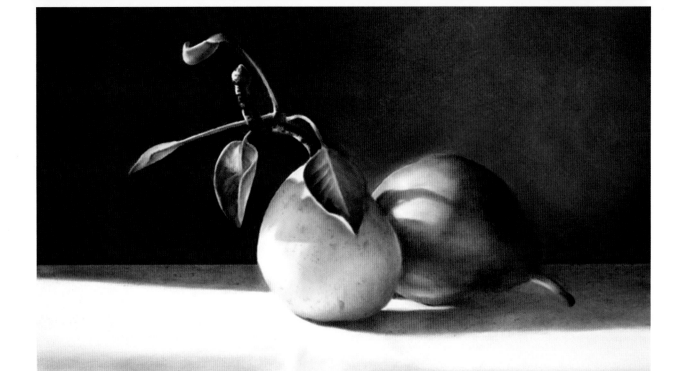

7 Glaze 7: Balancing the Values

To choose your final glaze, squint at your painting and compare the subject values with the background values. Are they balanced? Are the pears too light or is the background too dark? If you still need more color on the pears, paint a glaze of Alizarin Crimson on the red pear and a Sap Green glaze on the green pear. Be careful blending the edges of your glazes so that you don't cover up the pretty yellow on the green pear, or the pink areas of the red pear.

Use a mixture of Alizarin Crimson and Sap Green to deepen the values on the stems and where the leaves curl. Also add a touch of the mixture to the stem's end nearest the table.

With transparent backgrounds, a second glaze over the whole area will even out any streaks and help soften edges, if needed. For the final background glaze, create a dark blue-black mixture of Alizarin Blue Lake, Alizarin Crimson and Sap Green. Scrub the edges of the stems as shown on page 43. This will keep them from looking pasted on.

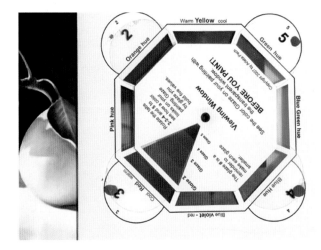

The Glazing Viewer and _Two Pears_

I laid the red viewing window over the red pear to get an idea what another red glaze would look like. The viewer helps me feel confident that my glazes are just right. See page 34 for more information on how the viewer works.

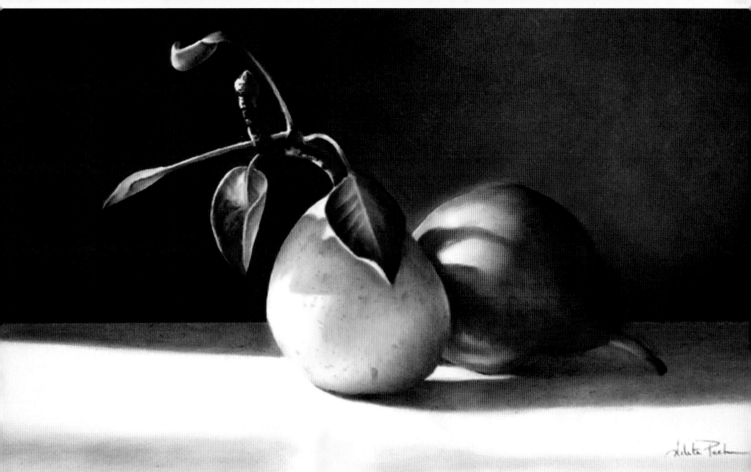

Two Pears 🍐 8" × 13" (20cm × 33cm)
Oil on board 🍐 Collection of the artist

8 The Final Painting

Congratulations! If you have followed these steps then you have created a full range of values on the two pears. Building form through value glazes is the foundation of realistic painting. Use this demonstration as a reference for painting any subject. Make sure to watch for subtle changes from light to dark and take your time. Always let your glazes dry fully overnight.

Fruitilicious ✎ 12" × 34" (30cm × 86cm)
Oil on canvas ✎ Collection of the artist

MANY TIMES I'VE BEEN ASKED BY ARTISTS HOW TO PAINT
a specific type of fruit or flower. There is no magical technique for paint-
ing the different objects in this world. You can create any realistic image
by mastering four elements: painting with a range of values, drawing
accurate shapes, painting the colors you see and using a variety of edges.

This chapter will focus on these four elements as we practice building
glazes. Each of the simple fruit studies was photographed in full sunlight
and painted on Ampersand 5" × 7" (13cm × 18cm) gesso boards, but you
can enlarge the drawings to any size you want.

Cherries, Raspberries, Blueberries

Shiny cherries, bumpy raspberries and frosted blueberries. The key to painting fruit realistically is to study the type of skin each fruit has. The bumpy texture of raspberries and shine of the cherries is created by accentuating a variety of values and edges with many glazing layers, while the crisp cool color of frosted blueberries rounds out the composition by contrasting with the red fruit. By building your values through many glazes, your subjects will appear luminous and unique in color.

Materials list

colors
Alizarin Blue Lake

Alizarin Crimson

Bright Red

Indian Yellow

Quinacridone Red

Sap Green

Winsor Orange

brushes
various sizes of filberts, mops and scrubbers (see page 11)

medium
select a medium that works well with your brand and type of oil paint (see chart on page 15)

tools
tracing paper

pencil

palette knife

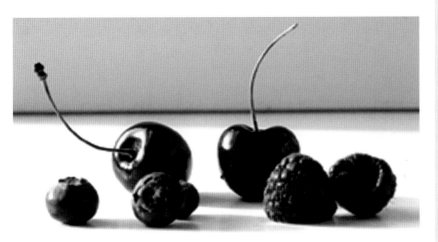

Reference Photo

Draw Your Composition

Transfer your drawing or draw your composition directly onto a prepared canvas using a hard pencil. Keep in mind that cherries and blueberries are not always round and that all of the bumps and holes of raspberries make for irregular shapes.

1 Glaze 1: Establishing the Forms and Highlights

The first glaze establishes the white highlights and the form of the fruit. You want to save much of the white of the canvas, so go easy as you apply the paint. If you can see the paint on the brush you have too much.

Values: Begin by glazing the dark values of each piece of fruit with a no. 6 filbert and blend with a 1-inch (25mm) mop to create lighter values. Thin the paint with a bit of medium. Use a blending brush when you want the glaze to be lighter, but don't load your brush too heavy.

Edges: Paint hard edges around the cherry highlights (still the white of the board), and lightly blend the soft edges of the shadows. The raspberries have highlights on their bumps and the edge of the stem hole, but you don't have to paint around all of them. The blueberries have both hard and soft edges depending on how the light catches the tops.

GLAZE 1 COLORS
Cherries: Winsor Orange (fruit), Sap Green (stems)
Raspberries: Quinacridone Red
Blueberries: Alizarin Blue Lake
Cast shadow: Alizarin Blue Lake

2 Glaze 2: Adding Warm and Cool Values

Mix some warm and cool values to create different reds for the cherries and raspberries. A yellow glaze on the raspberries will warm them and move them forward; a cool red glaze will move the cherries back.

Shapes: The outside shape of the cherries is strong from the first step, so you don't have to think about them again. As you paint, think about the tiny shapes of texture on the raspberries and the split tops of the blueberries.

Values: A darker red value will make the cherry skins shiny and help the lighter values glow. Similarly, raspberries have lighter values between the bumps to give them an inner glow. Blueberries are very dark, so the Alizarin Crimson glaze darkens the blue.

Edges: Adjust each glaze near the edges of the cherry and blueberry highlights if they are near a darker color. Paint around a few more highlights on the raspberries to add value and color dimension to the overall shapes.

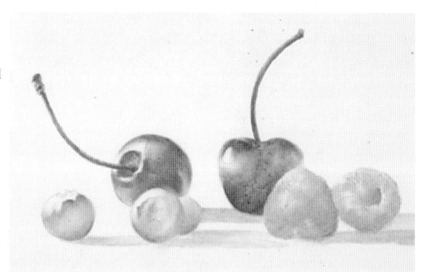

GLAZE 2 COLORS
Cherries: Alizarin Crimson to start building a darker red for the fruit and stems

Raspberries: Indian Yellow to add a warm glow that will show between the red bumps

Blueberries: Alizarin Crimson for the dull purple in the shadow areas

Cast shadow: A very light glaze of Sap Green as a complement to the red

3 Glaze 3: Creating Different Values Between the Fruits

This third glaze will start to separate the cherries from the raspberries. Repeat a glaze of color to make a cool or warm color more dominant.

Values: Make the cherries a deeper and colder red. Avoid painting over the lighter areas or you may lose the shine of the skin. Glaze Quinacridone Red on the raspberries to create more bumps. Make sure to leave a bit of yellow showing. Apply more staining colors such as Alizarin Crimson and Alizarin Blue Lake to darken the blue values of the blueberries.

Edges: Use a light touch on the soft edge highlights of the blueberries and cherries. Use a Quinacridone Red glaze to paint around a few bump highlights on the raspberries to help raise them up. As you build the glaze, sharpen the outside edges of each object, but don't completely outline the fruit.

GLAZE 3 COLORS

Cherries: Alizarin Crimson for the fruit; repeat Sap Green on the stems

Raspberries: Quinacridone Red for the warm red bumps

Blueberries: Alizarin Blue Lake for a frosty blue color

Cast shadow: Alizarin Blue Lake adds cool tone to the shadows

Create Interesting Shadows

Try for a variety of colors in your cast shadows. Why not mix one shadow color and get it over with? Because that makes shadows lifeless.

4 Glaze 4: Continuing to Develop the Fruit

The fourth glaze is where the layers finally start revealing a value difference. This is typical with transparent glazing. As you move forward, use semitransparent pigments to avoid blocking the luminosity of your previous layers.

Values: When painting the fourth glaze, be careful not to cover the first three glazes, otherwise you risk flattening out the fruit and you will have to start building form again.

Edges: Keep the edges of the raspberry bumps on the softer, shadowy side and only create hard edges on a few. Too many bumps and they will look like they have measles; too few and they will appear flat.

GLAZE 4 COLORS

Cherries: Bright Red for the fruit; Alizarin Blue Lake for the stems

Raspberries: Alizarin Crimson on the shadow side only

Blueberries: Mixture of Alizarin Blue Lake, Alizarin Crimson and Sap Green to deepen the value nearest the highlights

Cast shadow: Keep the cast shadow a cold blue. Lightly place Alizarin Crimson below the cherry or raspberries

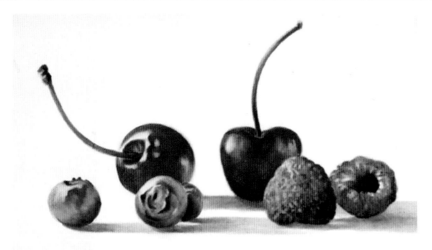

GLAZE 5 COLORS

Cherries: Alizarin Crimson to dull the bright tones of the fruit. Sap Green to cool and dull the shadow area on the front of the cherries and behind the stem. Cool the stems with Alizarin Blue Lake, dull them with Quinacridone Red or brighten them with Sap Green

Raspberries: Alizarin Blue Lake to deepen the shadows near the table

Blueberries: Alizarin Crimson to deepen the purple of the blueberry parts in shadow

Cast shadow: Mixture from fourth glaze to darken a small portion of the shadow right under the berries

5 Glaze 5: Dulling the Brightest Tones

After building four values of glazes, the colors will be bright. Dull a few areas to add depth before the final glaze.

Values: Use a complementary glaze to dull your brightest values and add to the round form of the fruits.

Edges: Clean up your edges during this glaze. Sharpen an edge near a highlight or glaze over a highlight to soften the value. Be careful, it is easy to get carried away and cover the entire fruit. Make sure to leave plenty of the previous glazes showing.

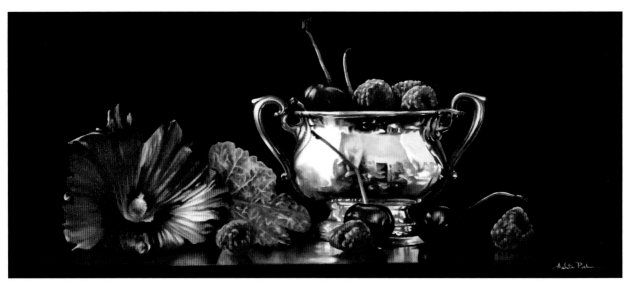

Summer Treats ❧ 14" × 22" (36cm × 56cm)
Oil on board ❧ Collection of Michael Taylor

Create a Composition With Reflections
Summer Treats was painted with a four-color theme—red, black, green and silver. Reflecting the colors in silver is both fun and challenging.

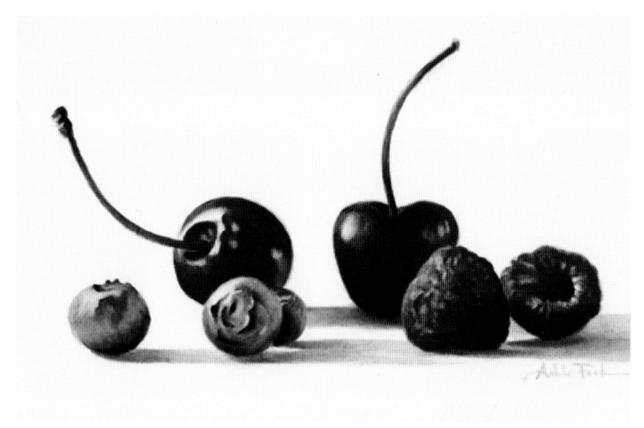

Berries ✒ 5" × 7" (13cm × 18cm)
Oil on board

6 *Glaze 6: Making Final Adjustments*
This last layer—as with any painting—is for tiny adjustments. Here I darkened the cherry with a small glaze to visually secure it in the background. I hope you have achieved shiny cherries, smooth blueberries and bumpy raspberries.

GLAZE 6 COLORS
Cherries: Alizarin Crimson mixed with Alizarin Blue Lake for a deep purplish red

Raspberries: A thin Bright Red glaze over the bumps and shadow to simplify them without making them go flat

Blueberries: A deep value of Alizarin Crimson near their base to anchor them to the table surface

Red Rosebud

Building deep red values by transparent glazing takes a lot of patience. The curl of a rose's petals is what sets it apart from other blooms. Careful glazing will help you achieve realistic edges and curves. The color red can be challenging to photograph because it absorbs light. Many times you'll have orange highlights in your reference photos. Adjust your camera's settings or the arrangement of your still life to achieve varying light setups. For accurate reds, do a simple color study from life and refer to it when you are painting.

Materials list

colors
Alizarin Blue Lake
Alizarin Crimson
Bright Red
Indian Yellow
Permanent Rose
Sap Green

brushes
various sizes of filberts, mops and scrubbers (see page 11)

medium
select a medium that works well with your brand and type of oil paint (see chart on page 15)

tools
tracing paper
pencil
palette knife

Reference Photo

Draw Your Composition
The most important part of drawing a rose is how the petals are expressed and how they circle in the center. Take the time to figure out what each petal is doing and where it rolls and tucks into itself.

1 Glaze 1: Identifying the Colors Under the Red

Examine the red flower and ask yourself what colors you see under the obvious red. Does it have a pink or yellow glow? Is it blue? Whatever it is, choose that tone for your first glaze. This bottom glaze will impact how the red shines in the final layers.

Values: Paint a cool glaze of Permanent Rose in the darker areas of the center of the rose. Wipe off or change brushes and glaze a tiny bit of Indian Yellow in the highlight areas to create a slight temperature change of cool to warm. This temperature change will help begin the roll (or curve) of the petals.

Edges: With a complicated flower like a rose, paint one petal at a time to simplify it into more manageable shapes. The initial curve of a petal creates one hard edge. It then rolls and disappears into a shadow or stops at another edge.

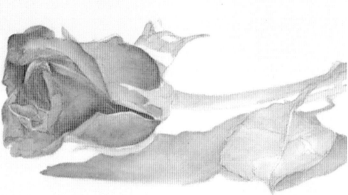

GLAZE 1 COLORS

Rose: Indian Yellow in the highlight areas; Permanent Rose in the deepest reds of the petals

Stem and leaf: Indian Yellow

Cast shadow: Permanent Rose and Sap Green; apply them separately then blend

2 Glaze 2: Establishing the Roll of the Petals

After the first glaze is dry, begin to darken the reds. A deep red will take many glazes of various mixtures, not just the same color.

Shapes: To paint a realistic rose, you must paint the roll of the petals on each and every glaze.

Values: Paint a second glaze of Permanent Rose in the darker areas of each petal and blend toward the yellow. Leave small areas of the previous yellow glaze showing.

Edges: Glaze over a few petal edges in the center of the rose. The dark crevice in the center is where a lost-and-found petal edge makes the rose look realistic.

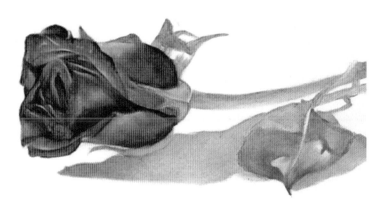

GLAZE 2 COLORS

Rose: Permanent Rose over the Indian Yellow glaze to create a soft orange

Stem and leaf: Sap Green on the edges of the stem; blend toward the lighter value to give it a round feel, and try to mirror the cast shadow

Cast shadow: Place Permanent Rose, Alizarin Blue Lake and Sap Green in separate areas and blend gently

Use Semitransparents in Early Glazes

Always use semitransparent colors in early glazes. Otherwise you risk ruining the luminosity of your glowing subject.

3 Glaze 3: Using Semitransparent Glazing

It's best to paint with semitransparent colors in your first few glazes. Painting values too dark or using heavy semitransparent colors will deaden the transparency of the glazes you have already painted, and make it tough to transition values in the later glazes. Always use medium to thin each value.

Values: Skip the third glaze in the cast shadow, and develop deeper values in the rose.

Edges: Use a sharp-edged filbert to glaze semitransparent Bright Red where each petal tucks under one another. Pay close attention to the edges between shapes.

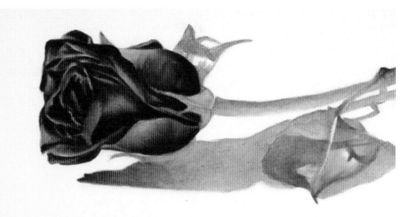

GLAZE 3 COLORS
Rose: Bright Red (semitransparent)
Stem and leaf: Alizarin Blue Lake for the cast shadow on the leaf

4 Glaze 4: Using a Stain to Deepen the Red

In the fourth glaze, a layer of Alizarin Crimson on top of the Bright Red will deepen the red value.

Values: Keep the cast shadow value in balance with the rose: too dark and it won't look like a shadow; too light and it won't give the feeling of light. Each glaze of the rose should be successively darker.

Edge: Pay attention to the edges that disappear. They will depend on how the light hits the rose.

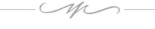

Use Mixtures for Tiny Studies

When you have a tiny area to paint, use a transparent mixture so it will add value with less work.

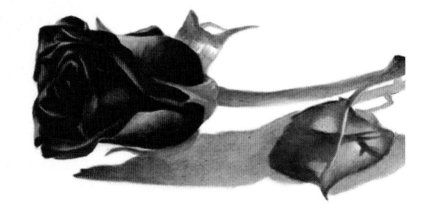

GLAZE 4 COLORS
Rose: Alizarin Crimson

Stem and leaf: Alizarin Crimson mixed with Sap Green

Cast shadow: Place a light glaze of Permanent Rose, Alizarin Blue Lake and Sap Green in separate areas and blend gently

5 Glaze 5: Adding Details

This glaze will make the contrast between the light and dark crevices really pop. Remember to glaze only a small area to allow the previous glaze to show.

Values: Keep this value in the crevice and the center of the rose. Glaze 5 is a good time to begin some details. I also changed the shape of the cast shadow on the leaf because it felt too one-sided.

Edges: Clean up your edges each time you glaze. For crisp edges, lay the paint in different patterns. Try to keep enough paint on your brush to cover the texture of the board.

Details: Roses have veins in their petals that may show up in certain light. Paint on a few veins where the light makes them show up on the top petal and soften their edges.

GLAZE 5 COLORS

Rose: A mixture of Alizarin Crimson and Sap Green over the darkest areas and for the petal details

Leaves: Sap Green mixed with a bit of Alizarin Crimson

6 Glaze 6: Darkening the Rose

Dull the cast shadow since it can't be as pretty as the rose. Add tips of red to the stems and the edge of the leaf.

Values: Paint a final glaze of dark red, almost black, over the darkest shapes of the rose. Do not glaze over the edges or you may destroy the form.

Paint in small areas. In the center of the rose, place a large glaze that crosses several petals to soften the complicated circle of petals.

Edges: Do a final cleanup of the edges with the last dark mixture. Work a little medium into a scrubber to push paint around or clean up a messy edge.

GLAZE 6 COLORS

Rose: Mix Alizarin Crimson, Alizarin Blue Lake and Sap Green for a dark red that leans toward black

Stem and leaf: Alizarin Crimson mixed with Sap Green near the darkest edges of the stem and leaf

Cast shadow: Dull the red shadow with Sap Green

Red Rosebud ✍ 5" × 7" (13cm × 18cm)
Oil on board

7 Glaze 7
After the sixth glaze has dried, use the reddish black mixture of glaze 6 to deepen the darkest crevices a final time. Let dry again and voilà!

Gerber Daisy

Multi-petal flowers are always a challenge to paint, especially in deciding where to start. There are no rules; pick a petal where you can see the light and dark values and start there. Keep it simple and select only one color for the first glaze. This way you only have to think about establishing the lights and darks and where one petal ends and another starts. If you try to think about more than this, it can be daunting.

Materials list

colors
Alizarin Blue Lake

Alizarin Crimson

Bright Red

Permanent Rose

Sap Green

brushes
various sizes of filberts, mops and scrubbers (see page 11)

medium
select a medium that works well with your brand and type of oil paint (see chart on page 15)

tools
tracing paper

pencil

palette knife

wipe out tool

Reference Photo

Draw Your Composition
Draw or trace your reference photo onto the board. Make sure to get all the petals.

1 *Glaze 1: Painting One Petal at a Time*
Each petal's value pattern is unique, so paint them that way. This is the most important part of the first glaze.

Shapes: With multi-petal flowers, take care with the overall shape of each petal, as well as its layering and placement. If you get lost as you work around the center, place a mark on your drawing or reference photo and count the petals from where you started.

Values: Painting one petal at a time, watch for patterns of light and dark; the dark petals are in shadow behind others. Do not outline the petals, but paint shapes with your glazes. Once you have blocked in a few, there will also be a noticeable pattern of light and dark as you work around the flower.

Edges: Glaze the right-side petals more simply and less detailed because of the way the light strikes them. Pay close attention to where the cast shadows create hard edges on the left side.

GLAZE 1 COLORS
Daisy: Permanent Rose

Center: Create light tones using a wipe out tool (see sidebar below) by moving around the wet pink paint

Cast shadow: Permanent Rose

Use a Wipe Out Tool to Add Details

A wipe out tool is great for creating details and sharp edges, or for fixing mistakes. It is essentially a paint brush handle with a beveled or pointy rubber tip on each end. Use the point of the wipe out tool to carve out a few highlight details in the center of the daisy. Don't try to do them all now. Use this technique on future glazes to create different values as you build the flower's center.

2 Glaze 2: Glazing the Cast Shadow

Always leave some of each previous glaze showing to create and build form. Use the wipe out tool again to make a few detailed spots of this new value in the center of the flower.

Shapes: With this second glaze the cast shadow shapes will become stronger and help to define the pattern and shape of the whole flower.

Values: There are no white highlights on the petals, only the detailed spots in the center, so pull this glaze out quite a bit. Leave a bit more of the first pink glaze showing on the petals on the lighter right side.

Edges: Focus on your hard edges on this glaze to establish the cast shadow edges.

GLAZE 2 COLORS
Daisy: Bright Red

Center: Use the wipe out tool to create more spots in the center

Cast shadow: Sap Green

3 Glaze 3: Cooling Down With Blue

Cool the deep pink tones of the first two glazes with a strong blue. You may choose to build this local color over two layers, letting each dry in between.

Values: Confine the dark blue to the darkest value areas, cast shadows and the center.

Edges: Paint around the highlight spots you created in step 1. Always clean up the edges as you do each new glaze.

GLAZE 3 COLORS
Daisy: Alizarin Blue Lake

Cast shadow: Alizarin Crimson

4 Glaze 4: Re-Glazing Large Areas

With multi-petal flowers, the individual petals may start to look like a jigsaw puzzle. If this happens, do a glaze over a large area of several petals to pull it back together.

Values: The previous value glazes should hold when you do a large glaze over several petals with Permanent Rose. Add some variety by blending the glaze lighter near the right side and darker toward the center of the flower.

Edges: Don't worry about edges in this large-area glaze. The goal of this glaze is to tint the light areas and soften the shadows.

GLAZE 4 COLORS
Daisy: Permanent Rose

Cast shadow: Alizarin Blue Lake

5 Glaze 5: Creating Variety in Petals

In the fifth glaze, return to painting petal by petal. Concentrate on the blue shadow areas from glaze 3 to develop their deep burgundy color.

Values: The shadow value is what creates the form of this flower, so the mixture needs to be painted mostly on the areas where you painted the blue glaze.

Edges: Create harder edges between the shadows. The back and forth between soft and hard edges will help you achieve realistic petals.

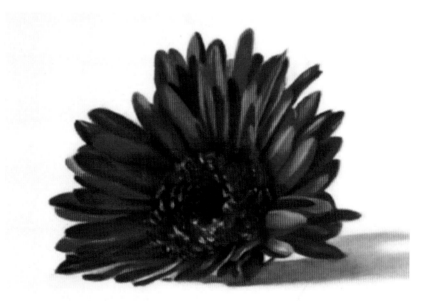

GLAZE 5 COLORS
Daisy: A mixture of Alizarin Crimson and a bit of Bright Red

Cast shadow: Dark mixture of Alizarin Crimson, Alizarin Blue Lake and Sap Green

6 Glaze 6: Finishing the Center

Concentrate on the center of the daisy to give the final painting depth and interest. Use a razor blade to scratch a bit of paint from the white highlights in the flower's center.

Values: Keep this value glaze in the center and a few points in the deepest crevices.

Edges: You may feel you need to use this mixture on a few tiny edges. OK, but don't get carried away and make hard lines.

GLAZE 6 COLORS
Center: A dark red mixture of Alizarin Crimson and a touch of Sap Green

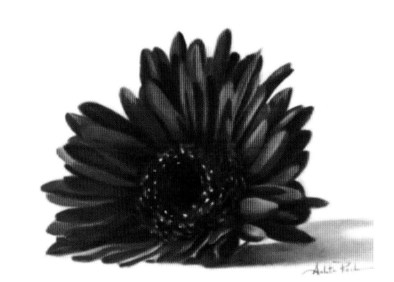

Gerber ❧ 5" × 7" (13cm × 18cm)
Oil on board

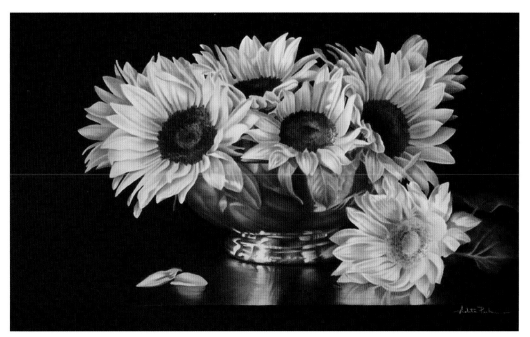

Golden Glory ❧ 14" × 22" (36cm × 56cm)
Oil on board ❧ Collection of Tim and Stacy Pech

A Bouquet of Multi-Petal Flowers

The white highlights sprinkled throughout the sunflowers in *Golden Glory* move the eye through this painting. When you have this many multi-petal flowers, decide which flowers are the most important and where to place the focal point. A few of the flowers will need to be glazed deeper to push them into the shadows or background.

Orange and Persimmon

Texture is vital to differentiating two similarly colored fruits. The trick to this exercise is the order of the value glazes, with two different orange colors glazed in different order to separate the two fruits. What's important to achieving realism here is the bumpy texture of the orange and the smooth edges of the persimmon.

Materials list

colors
Alizarin Blue Lake
Alizarin Crimson
Indian Yellow
Quinacridone Red
Sap Green
Transparent Yellow
Viridian Green
Winsor Orange

brushes
various sizes of filberts, mops and scrubbers (see page 11)

medium
select a medium that works well with your brand and type of oil paint (see chart on page 15)

tools
tracing paper
pencil
palette knife

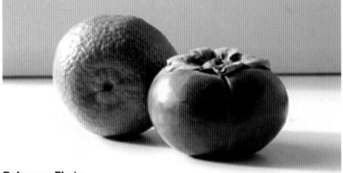

Reference Photo

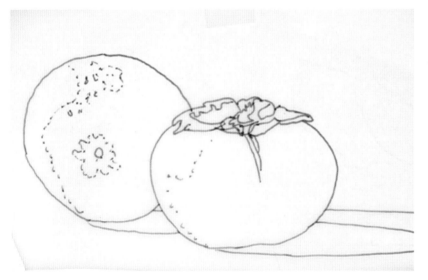

Drawing Your Composition
Draw or trace your composition on the board. Outline the shapes and major value areas.

1 Glaze 1: Distinguishing the Fruits

When glazing two similarly warm-colored objects, separate them from each other by glazing two colors. Apply them separately then blend gently with a soft mop. Leave some areas alone, creating a patchy pattern that shows the roughness of the orange's rind. Strive for a variety of edges.

Shapes: The orange is almost perfectly round, and the persimmon is a nice oval. Always look closely for the differences that make objects interesting.

Values: For the orange, place red where the values will eventually be darkest. Glaze a good amount of yellow toward the right side of the fruit and blend toward the left, leaving the white highlights. Do this for the persimmon, as well, but blend toward the bottom. The green on the top of the persimmon is glazed in smaller shapes, so be careful with how much paint you have on your brush.

Edges: The orange has a lot of texture, so create its white shapes on the left side of the highlight area.

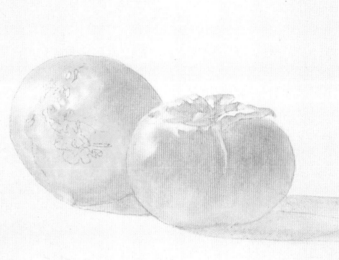

GLAZE 1 COLORS

Orange and persimmon: Transparent Yellow and Quinacridone Red placed separately to distinguish the two fruits

Persimmon top and crevice: Viridian Green

Cast shadow: Alizarin Blue Lake and a bit of Quinacridone Red, but mostly blue shadows to complement the warm oranges

2 Glaze 2: Creating Texture

The goal of the second glaze is to create dramatic texture, so apply a variety of shapes. Don't get caught up trying to replicate the photo exactly. Instead squint your eyes so you can simplify the number of shapes and see the overall value pattern.

Shapes: Paint a variety of shapes and sizes of the orange texture. You will repeat this in the next glaze, so don't paint every shape you see.

Values: Glaze Quinacridone Red in the middle of the persimmon and blend on all sides. Stop blending in time to leave plenty of the first glaze showing.

Edges: Dab some paint then lightly blend part of the edge to achieve a variety of soft and hard edges (see the result in the sidebar on page 72).

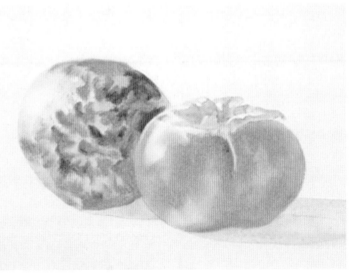

GLAZE 2 COLORS

Orange: Transparent Yellow and Winsor Orange

Persimmon: Quinacridone Red

The Dab-and-Blend Technique

The dab-and-blend technique is useful for creating texture. Dab some paint on the board and lightly blend part of the edge to create a variety of hard and soft edges. Make sure to blend gently so you don't create a solid color area and lose the form.

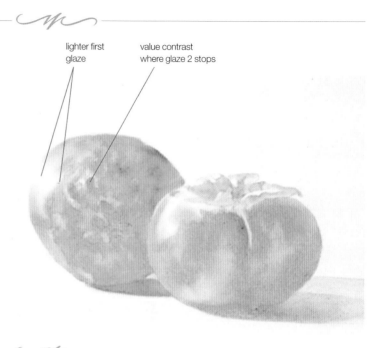

lighter first glaze

value contrast where glaze 2 stops

3 Glaze 3: Blending to Make the Fruit Rounder

Continue to build values in glaze 3. Take time to study each previous glaze to determine what your painting needs.

Shapes: Concentrate on building the orange's roundness. Reinforce the shapes of the orange texture from glaze 2.

Values: Further separate the orange from the persimmon with a light glaze of Indian Yellow. Continue to deepen the value in the center of the persimmon with a blended glaze of Quinacridone Red.

Edges: There should be no edges on these glazes. Blend them so they disappear on both pieces of fruit.

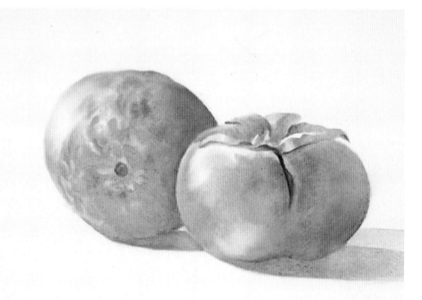

GLAZE 3 COLORS

Orange: Indian Yellow

Persimmon: Quinacridone Red

Persimmon top and crevice: Alizarin Blue Lake

Cast shadow: Use Quinacridone Red for the orange and a combination glaze of Alizarin Blue Lake and Quinacridone Red for the persimmon

4 Glaze 4: Building Value Contrast

Value changes can be created by contrasting cool and warm colors, so look for areas where you can use this idea. The persimmon is a great exercise for this during these final glazes.

Values: On the orange use the Alizarin Crimson for the orange-red area. On the persimmon, glaze cool and warm colors separately in needed areas.

Edges: Smooth all of the persimmon's edges, except for the split in the skin and the top. On the orange you can decide if you need to use more colors to create more texture using the dab-and-blend technique.

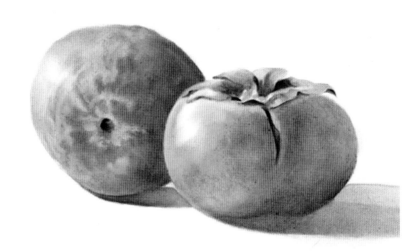

GLAZE 4 COLORS
Orange: Winsor Orange mixed with Alizarin Crimson

Persimmon: Alizarin Crimson, Alizarin Blue Lake, Winsor Orange

Persimmon top and crevice: Alizarin Crimson

Cast shadow: Alizarin Blue Lake

5 Glaze 5: Smoothing Edges With a Large Glaze

At this stage, glazing on top of color can sometimes look choppy if a glaze hasn't been softened enough. If this happens, take a lighter transparent color such as Indian Yellow or Quinacridone Red and create a large glaze across almost the entire fruit except the white highlights. This will smooth out the delicate edges of the glazes. Skim the surface of the painted layers with a delicate touch.

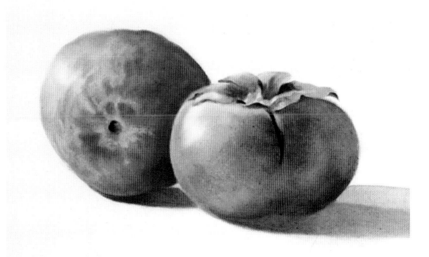

GLAZE 5 COLORS
Orange: Quinacridone Red mixed with Indian Yellow

Persimmon: Indian Yellow mixed with Quinacridone Red

Persimmon top and crevice: Viridian Green

Cast shadow: Alizarin Crimson for the orange, Alizarin Blue Lake for the persimmon

6 Glaze 6: Making Final Adjustments

In the final glazing, make small color adjustments depending on how your fruit looks. Here, I chose to cool and darken the deep orange tones with a red glaze, followed by a blue glaze to keep the tones cool and purple. If your last glaze was yellow on orange followed by blue, the result would be muddy and green. Refer to your color charts to help you decide what color is best during these final stages.

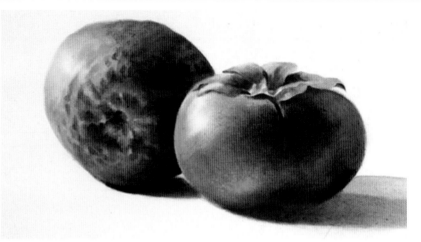

GLAZE 6 COLORS

Orange: Alizarin Crimson, then Alizarin Blue Lake

Persimmon: Alizarin Crimson mixed with Quinacridone Red for the deepest red area

Persimmon crevice: For a darker hue, mix a black with a red, green and blue (see page 37 for information on dark background mixtures)

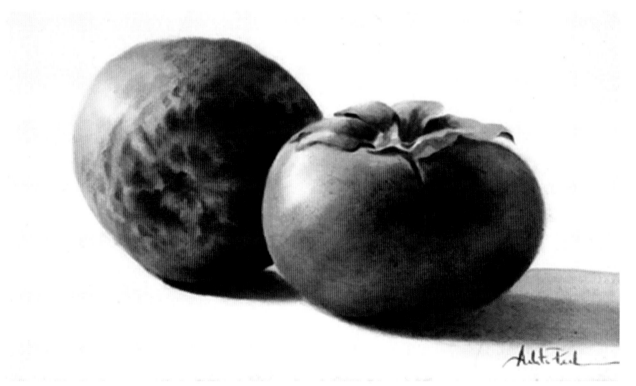

Orange Friends ✍ 5" × 7" (13cm × 18cm)
Oil on board

7 Glaze 7: The Finished Painting

Cool the deepest areas of each fruit's base with a final glaze of Alizarin Blue Lake.

GLAZE 7 COLORS

Orange: Alizarin Crimson under the orange

Persimmon: Alizarin Blue Lake to cool the dark areas and Alizarin Crimson underneath; Viridian Green on the top

Apple and Banana With Transparent Grapes

So far we have learned to create the illusion of solid objects through glazing. But what about more transparent objects such as glass or, in this case, grapes? For these types of objects, very thin values create this effect. Each grape has its own unique pattern of light to dark, depending on how the light glows through the grape. After the previous fruit and flower studies, you should be prepared to tackle these transparent green grapes.

Materials list

colors
Alizarin Blue Lake
Alizarin Crimson
Bright Red
Indian Yellow
Quinacridone Red
Sap Green
Transparent Yellow

brushes
various sizes of filberts, mops and scrubbers (see page 11)

medium
select a medium that works well with your brand and type of oil paint (see chart on page 15)

tools
tracing paper
pencil
palette knife

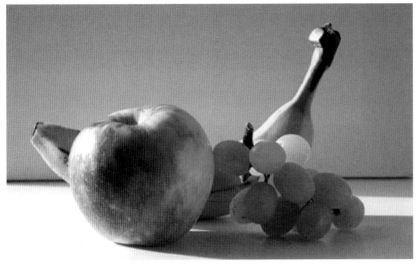

Reference Photo

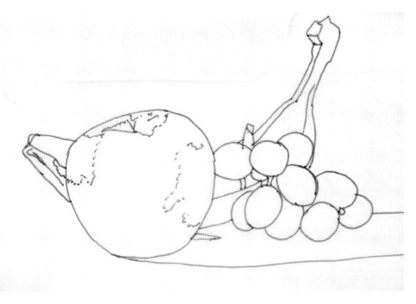

Draw Your Composition
Draw or trace your composition on the board. Outline the shapes and major value areas.

1 Glaze 1: Using Different Values in the Base Color

When several objects or flower petals have the same base color glowing through, keep that color consistent in the first glaze.

Shapes: When you have similar colors in objects, the outside of the shapes is less important than the value changes and the shapes of the highlights. Keep that in mind during the first glaze.

Values: Each grape should have a different value pattern for this first glaze of yellow. Leave some extra white or pale yellow areas on the apple to create bounced light from the table and grapes.

Edges: There are no hard edges or strong cast shadows in the grapes, only soft edges. The banana does have hard edges, so it is easier to stop and start the glazes that follow its shape.

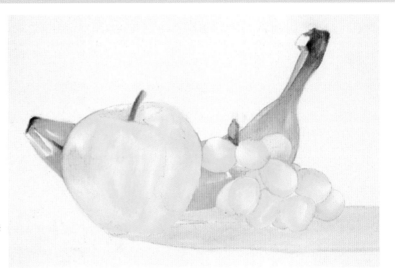

GLAZE 1 COLORS

Apple: Transparent Yellow

Banana: Indian Yellow

Grapes: Transparent Yellow

Stems: Alizarin Crimson (apple, grapes); Alizarin Crimson mixed with Alizarin Blue Lake (banana)

2 Glaze 2: Adding Color Glazes

When the base color dries, set the objects apart with the second glaze. Leave more yellow showing if a grape is in full light; if a grape is in full shadow, cover it a bit more.

Shapes: For realistic texture, create variety in the sizes of each of the painted shapes.

Values: The apple's Quinacridone Red glaze needs to be very delicate in order to create a pink value near the yellow value. A glaze of green on the banana near its stem and in the shadow helps to darken its overall value. For the grapes in shadow, the blue should cover quite a bit of the yellow glaze. Grapes sitting in the light require a yellow glaze to warm them and make them lighter.

Edges: All glaze edges are still smooth except for the highlight shapes on the top edge of the banana.

GLAZE 2 COLORS

Apple: Quinacridone Red

Banana: Sap Green

Grapes: Alizarin Blue Lake

Stems: A mixture of Alizarin Crimson, Sap Green and Indian Yellow

Preserve the White of the Board

It's a good habit to always leave more white than you think you might need. You can always tone it later with a thin glaze of color.

3 Glaze 3: Glazing Red on All the Fruit

It's time to add a glaze of red to each object, even the green grapes. It's this third layer that will eventually make gray. All objects have some gray in them; it helps create shading.

Values: On the apple, glaze a cooler red of Alizarin Crimson. We will build warmer red values in following glazes. Also use Alizarin Crimson where the banana looks orange, and a tiny bit on the grapes for shading.

Edges: The edges are still soft overall, but start building streaks of color on the apple. Soften some of the harder streaks so they are not all the same.

GLAZE 3 COLORS

Apple: Alizarin Crimson

Banana: Alizarin Crimson

Grapes: Alizarin Crimson

Stems: Depending on the color of the stems at this point, either mix a color from the previous step or just glaze one color

4 Glaze 4: Making Colors Vibrant

This fourth glaze is where the colors really pop. It's one of my favorite steps.

Values: Continue to round the apple by blending a red value outward from the center of the fruit. Also add the red tone to the left of the stem. Make sure to steer clear of the highlight to the right of the stem; it is vital to the apple's round shape. Each glaze on the banana near the stem builds up its dark value. Try hard to achieve tiny glazes on the grapes. You don't want to lose the glow by pulling across too big an area.

GLAZE 4 COLORS

Apple: Bright Red in some areas, and Indian Yellow for the warm areas and on the shady side

Banana: Indian Yellow

Grapes: Indian Yellow with a touch of Alizarin Blue Lake for a subtle green

5 Glaze 5: Building Up the Colors

By now, each glaze should be getting smaller, building rich color on each object. Remember, it's the final glaze that affects the hue or tint of the object. So, if you want your banana to be greener, do a blue glaze on top of the yellow. If you want it to be red-orange, glaze red on the top of the yellow glaze. Do you want the apple to have a green tint on the shady side? Add a thin glaze of blue on top of the yellow glaze. Here, the last glaze on the apple was red, so a yellow glaze is needed before a blue one.

GLAZE 5 COLORS

Apple: Bright Red in the warm red areas, Alizarin Blue Lake on the shadow side and where the stem drops into the apple

Banana: Alizarin Crimson on top of the yellow to create the red-orange reflections of the apple

Grapes: Sap Green to cool the grapes and on top of the Alizarin Crimson to add depth to the shadows

Stems: A mixture of Alizarin Crimson and Sap Green to create a heavier stem in the center of the grapes

6 Glaze 6: Making Color Adjustments

During these final glazes, decide what your fruit needs in terms of color. Each artist paints glazes with different intensities. Perhaps your reds are a little heavier. Or maybe you need to balance out the yellow on the apple, or the green on the banana or grapes. Depending on how your study looks compared to this example, you may need to vary your final color glazes.

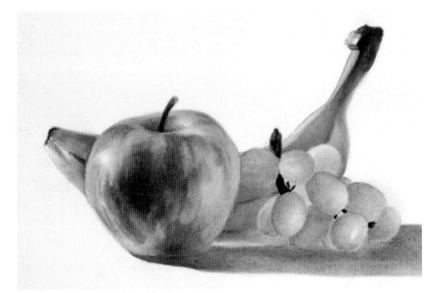

GLAZE 6 COLORS

Apple: Indian Yellow

Banana: Sap Green

Grapes: Indian Yellow

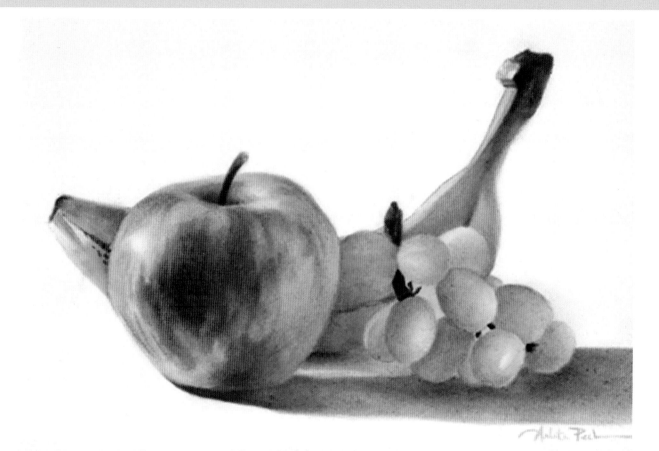

Primary Fruits 🖌 5" × 7" (13cm × 18cm)
Oil on board

7 Glaze 7: Adding the Final Details

For the final details, I cooled the shadow side of the apple and grapes with a light glaze of Alizarin Blue Lake. Study your painting and decide where you need to make adjustments.

Final Thoughts on Fruit and Flower Studies

Though it took about seven glazes to complete each of these fruit studies, there are no hard-and-fast rules about the total number. If these studies had been created with a medium or dark value background then we might have needed ten glazes to finish each painting. Learn to look at the balance of a painting's values in relationship to the value of the background. When in doubt, squint. Does your subject look pale and washed out compared to the background? Then adjust the values with more glazes. Do you prefer to build your glazes faster with deeper colors? Then stop a little early when you've reached the proper balance between your subject and background.

Take your painting to another area of your home or studio, set it up and glance at it as you sit and watch TV or cook. Look at your painting in different types of lighting, natural and artificial. If you move it around and it looks balanced and finished in all types of light, then it will be enjoyed for years to come in any setting.

Four Demonstrations

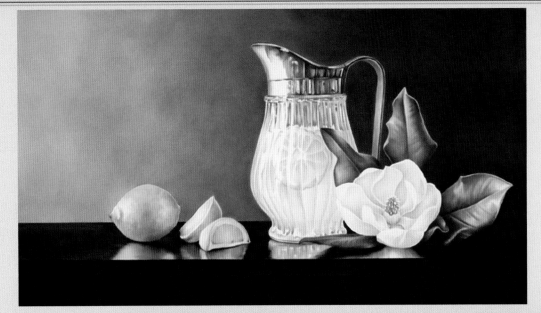

Summer Comfort
North light shows
soft colors and very
close values.

Sweet Perfection
Use a spotlight for
dramatic lighting
effects and compli-
cated subjects.

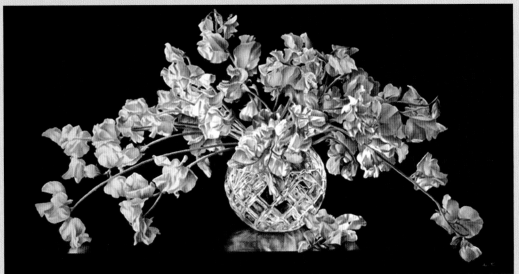

THE FOCUS OF THESE FOUR DEMONSTRATIONS
is light. Light can alter and enhance images and affect how
the subject appears to the viewer. These demonstrations
will show you how light affects the painting process.

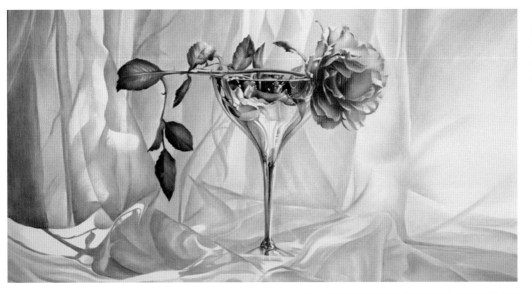

Sheer Reflections
Transparent materials are a great subject matter for mastering folds and shadows.

Lemon-Lime Soda: Light Source from Behind and Left
Backlit images (left) are some of the most challenging to paint. You can simply move the light to the left (below) and get a completely different composition.

81

Inspiration plays a big role in creating paintings that will appeal to you and your viewers. I found this pitcher at an antiques store and it inspired the summery lemonade theme. Placing a lemon slice inside the pitcher tickled my creative muse. Setting the still life near a north window allowed the lemon slice to show. If I had set it up in strong sunlight it would have been challenging to capture the delicate color of the lemonade and the soft color in the magnolia. It's a good idea to try different light settings because the light plays such an important role in how your painting will look.

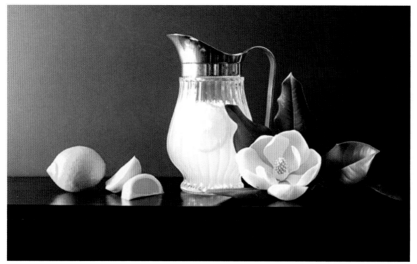

Reference Photo

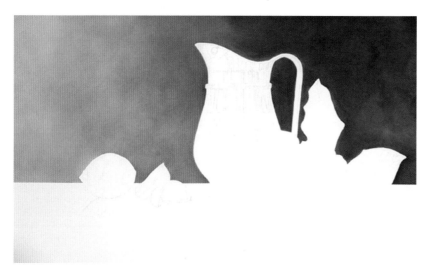

Prepare the Background
Begin the drawing with a soft gray pastel pencil on a prepared panel. The green background color is mixed with Ultramarine Blue and Transparent Gold Ochre. Use the background blending technique (pages 38 and 39) to change the overall value from dark to light.

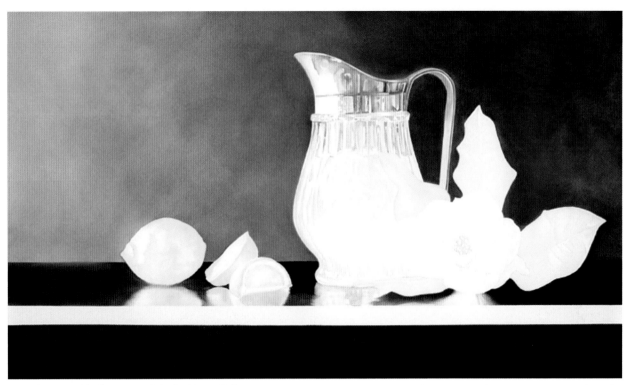

1 Glaze 1: Blocking In With the Base Color

Blocking in the first glaze is always about saving the white of the canvas. It's also when you establish a light version of the local color. Pay close attention to soft and hard edges, such as the top silver of the pitcher.

Magnolia: Mix Ultramarine Blue with a touch of medium to create a light blue value for the base color of the blossom. The warm flower color is a mixture of Burnt Sienna and Ultramarine Blue; it will help establish a light value pattern on each petal that shows off the white highlight areas. The flower's green center is Ultramarine Blue mixed with Transparent Gold Ochre .

Leaves: The shiny blue near the highlights is the lightest color of the leaves, so this should be the first glaze. Mix Phthalo Blue with medium to create a light value, and retain plenty of white areas as you glaze.

Lemons: The base glaze is Transparent Yellow. This includes the lemon slice in the pitcher—the blue glaze of the pitcher has to be on top of the yellow to gray the lemon and visually push the slice into the lemonade.

Pitcher base: Mix a dark gray-green from Phthalo Blue and Burnt Sienna for the upper glass areas. The cool green tone of this mixture will help the background color show though the glass.

Lemonade: The first glaze of the cool blue lemonade area is a blue mixture of Ultramarine Blue and Burnt Sienna.

Pitcher top: The pitcher top consists of three mixtures: the two used in the glass of the pitcher, and a third warmer green mix of Ultramarine Blue and Transparent Gold Ochre. Use a clean brush for each one and block in the pitcher top one shape at a time. Pay attention to the edges of each shape—hard or soft, warm or cool. Determine which color combination to use. Metal has a lot of hard edges in its reflections, but variety is important to keep it from looking like a zebra.

Table and reflection: Mask the straight edge of the table with tape—I prefer Scotch Magic Tape. Block the mass of table with a mixture of Alizarin Crimson, Sap Green and a tiny bit of Phthalo Blue. Paint a glaze of Alizarin Crimson for the red reflection directly under the spout of the pitcher.

Reflections: As you glaze the table, block the reflections of the subjects, then drag the paint down to create the reflections with a clean brush. They don't need to be perfect, they'll be repainted later. Allow the first glaze to dry completely overnight and remove the tape to create the front edge of the table. It will be glazed in the next step.

Mixing a Gray

Ultramarine Blue (Green Shade) and Burnt Sienna are a great combination for mixing a gray. Mix with a medium to lighten the value.

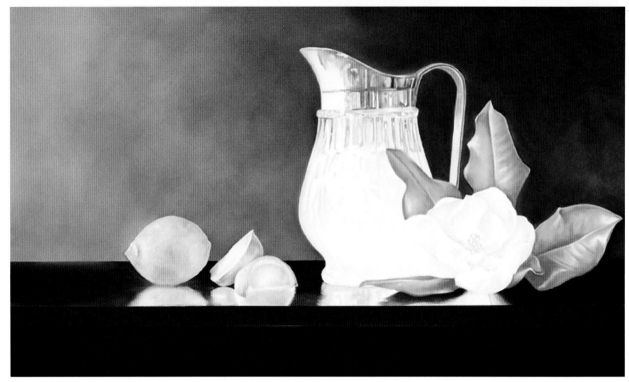

2 Glaze 2: Building the Colors and Texture

Block in the rest of the painting and develop the cast shadows. It's a nice feeling to be able to really assess the overall highlights and color areas of your painting.

Magnolia: Mix Transparent Gold Ochre with the dark gray-green mixture of Phthalo Blue and Burnt Sienna used in the upper glass areas of the pitcher's first glaze. Since we started the magnolia with a cool glaze of blue, a warm second glaze of gray-green will keep the flower from getting too cold. Allow plenty of the first soft blue glaze to remain in view.

Leaves: Load one brush with a mixture of Phthalo Blue and Indian Yellow, and a second brush with Transparent Yellow. Apply the first mixture on the cool green areas of the leaf and Transparent Yellow next to it. Use a soft blending brush to work these two values both separately and together. Leave some areas of the first glaze of Phthalo Blue showing, as well as some of the white highlight areas.

Lemons: Use Transparent Gold Ochre on one brush and Transparent Yellow on another and softly blend the two values into the yellow areas. Allow areas of the first glaze to remain. Use the dab-and-blend technique (see page 72) to suggest the texture of the lemon peel's dimples. Use a soft mop brush to soften some of the texture; plan to do this texture technique with each value.

Table: Apply a mixture of Alizarin Crimson, Burnt Sienna and Alizarin Blue Lake to the edge of the table, paying close attention to the dark to light value change that happens between the top and the edge, as well as the left side of the table to the right.

Blend Gently

Blend with a soft mop brush and stroke the area with a light touch. The goal is to smooth out streaks and create a soften a color.

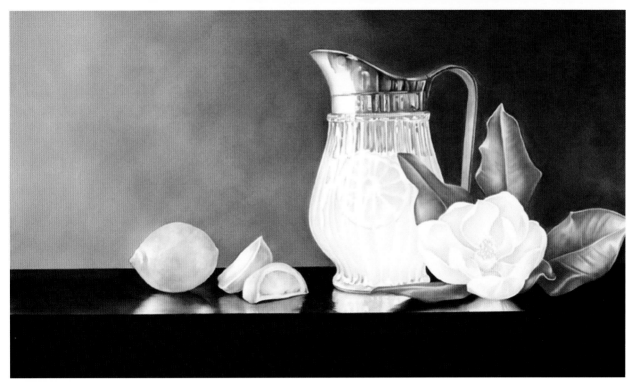

3 Glaze 3: Establishing Values

The third glaze is when we begin to deepen the value of the shapes of color. Not all shapes will get a deeper value treatment. The key is to leave plenty of the first two glazes showing to establish a wide value range as we continue to build values.

Pitcher base: Ultramarine Blue mixed with Transparent Gold Ochre adds depth to the shape of the glass.

Pitcher top: Use the same colors as the first glaze at a similar intensity to build and deepen the silver value.

Lemonade: Use Phthalo Blue mixed with medium to intensify the blue of the lemonade and play up the shape of the ribs in the glass.

Magnolia: Use a mixture of Ultramarine Blue, Phthalo Blue and Transparent Gold Ochre. For delicate values, it may be easier to mix transparent colors rather than doing individual color glazes.

Lemons: A glaze of Transparent Gold Ochre will deepen the shadow side on the lemon rinds. For the meat of the cut lemon, place a thin glaze of Phthalo Blue and a glaze of Burnt Sienna in different areas and blend them together.

Table underside: Glaze a cool mixture of Alizarin Crimson, Sap Green and Phthalo Blue in the shadowed area under the table ledge. Add more Alizarin Crimson to the mixture as you work down toward the bottom of the canvas.

Table edge: When painting the underside, don't get too close to the ledge and create a hard edge at the table ledge. Instead, tape off the ledge again and use the cool mixture from the underside nearest the edges, and the mixture warmed with Alizarin Crimson for the center of the ledge.

Table back edge: Add another layer of tape on the table edge in the background. Place a dark and cool mixture of Alizarin Crimson, Sap Green and Phthalo Blue on the left of the table and work your way to the right. Get lighter as you glaze, allowing more Phthalo Blue to show on the right. Allow the table area to dry before any more work is done on the reflected colors.

Reflections: Make sure that you don't blend too far into the reflection. Add a bit of Indian Yellow to the lemon reflection to warm the area. Blend a bit of the table color with Phthalo Blue to enhance the magnolia's reflection.

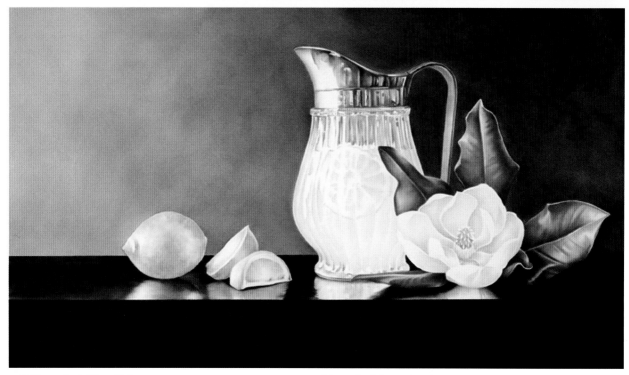

4 Glaze 4: Adding Colors

Take a good look at the painting now that the blocking in is completed. For the rest of the glazes, focus on playing with color glazes and building strong value patterns.

Magnolia: Mix a soft pink-gray with Permanent Rose, Burnt Sienna, Transparent Gold Ochre and a touch of Ultramarine Blue and warm the glaze near the center of the flower. Depending on the value adjustments your painting needs, you can also mix a yellow-gray by using a touch more Transparent Gold Ochre, or a blue-gray by using a touch more Ultramarine Blue. These mixtures are useful for any white or fleshy colors.

Leaves: Create a dark mixture of Sap Green and Ultramarine Blue and glaze in the areas that need deepening, especially the shadows. This layering of warm and cool greens makes the leaves pop.

Lemons: The meat of the lemon has so many colors—green, pink, yellow-green—it's fun to include them all. Paint an individual glaze of Burnt Sienna where the table and lemon reflections meet. Glaze a mixture of Phthalo Blue and Transparent Gold Ochre over the deeper yellow areas.

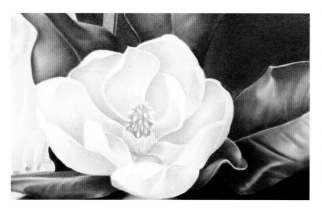

The Magnolia's Fifth Glaze

Using a clean brush, glaze Phthalo Blue into the deepest parts of the crevices where the petals tuck under one another. This should be a delicate, thin glaze. Glaze the magnolia's fuzzy center with a mixture of Phthalo Blue and a touch of Burnt Sienna.

For the petals, alternate between warm and cool glazes of the petal's previous mixtures, depending on how the flower looks. There are no rules; you may choose to do several warm glazes before using a cool glaze, or any other combination. With such a soft white flower, keeping the glazes very light is key. Too heavy of one value glaze and you may lose the delicate balance of color.

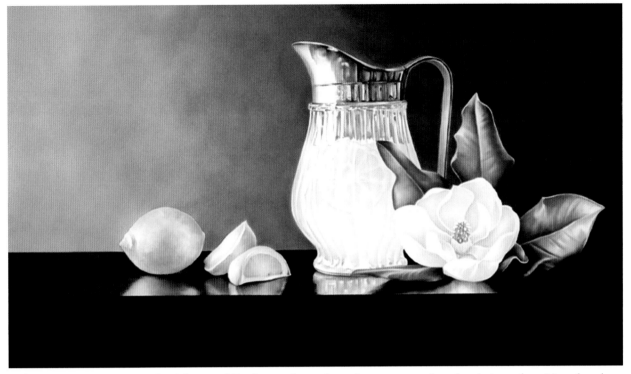

5 Glaze 5: Strengthening the Values and Background

The painting starts to come together around the fifth glaze. It is OK to use staining transparent colors in these later glazes to strengthen the glazing values. Now that the painting's values are deep enough, place another glaze on the background.

Lemons: Use Alizarin Crimson on the shadow side of the big lemon. Glaze Indian Yellow into the corners of the meat of the sliced lemon. Also glaze some Sap Green in this area and on the rind, but do not overlap the two colors. Glaze Alizarin Crimson onto the rind of the middle lemon slice to create the curve of its edge.

Leaves: Complement the green of the leaves with a dark glaze of Alizarin Crimson. Apply it to the darkest areas of the leaves and blend out, but not so much that it covers the previous values.

Lemon reflection: Create a mixture of Alizarin Crimson, Sap Green and a bit of Phthalo Blue to deepen the table reflection under the lemons. Darken the reflection edge of the lemon and blend in a bit of Indian Yellow using a clean synthetic filbert. Keep your reflection strokes horizontal to move with the tabletop.

Pitcher reflection: Create a mixture of Ultramarine Blue, Transparent Gold Ochre and a touch of Phthalo Blue to cool the gray-green under the pitcher.

Magnolia reflection: Use the same gray-green and the Alizarin Crimson and Sap Green mix. Repeating the same color makes the painting work together. Keep this deeper color glaze on the right side of the reflection so there is a value transition before seeing the dark side of the table.

Pitcher base: Darken the indentations of the glass near the lemon-ade with Ultramarine Blue mixed with Transparent Gold Ochre. Pay close attention to the light and dark sides of these indentations and how the light falls on them. Blend the deep values to the top of the pitcher. A few indentations cross over the lemon slice, turning it green and pushing it into the pitcher and lemonade. Note that the round shape of the lemon slice is broken up by the shape of the glass. Keep this broken up.

Lemonade: Paint a glaze of Phthalo Blue to deepen the lemonade mixture as well as the top of the pitcher. If needed, tint a few of the white shapes such as those on the right shadow side of the pitcher.

Pitcher top: Mix a black from Alizarin Crimson, Sap Green and Phthalo Blue and glaze into the small darker shapes of the pitcher top. Use the gray-green mixture from the pitcher reflection and a blending brush to tint the whites in the shadow areas.

Table: Use this same black mixture to glaze a tiny area in the deep value areas of the leaves and the dark reflection area under the lemons. Apply tape on the bottom edge of the table and deepen the shadows under the table. Aim for soft edges. Darken the left and right edges of the table so the eye does not leave the painting.

Background: Add a bit of Sap Green to the black pitcher top mixture to create a deep green-black. Mix the value with a touch of medium on a no. 14 flat to apply this glaze on the right side. Glaze over the tabletop on the right into the background using circle motions. Where you wish to lighten the black value, blend with a soft blending brush. Blend this value to the left beyond the left side of the pitcher.

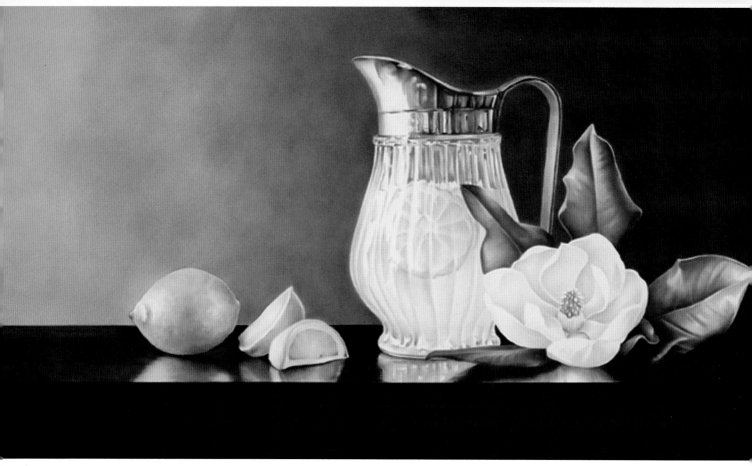

Summer Comfort ✍ 17" × 29" (43cm × 74cm)
Oil on board ✍ Private collection

6 Glaze 6: The Finishing Glazes

These last glazes are value adjustments, toning a white shape or adjusting to make a shape warm or cool. Learn to look at the edges of an object next to another object. Does one need to be darker, warmer or cooler? These are the decisions you make during your final glazes.

Magnolia: Glaze Phthalo Blue mixed with Burnt Sienna in the smallest areas.

Whole lemon: Glaze 5 was a cool red, so complement the shadow areas with a glaze of Sap Green.

Lemon slices: Glaze Indian Yellow on the warm side of the meaty section of the right lemon slice. Place a glaze of Ultramarine Blue on the lower edge of the rind. The white shape of the sliced middle lemon is pulling the eye away from the painting's center of interest, so tone it down with a light glaze of Indian Yellow. One way to decide if a white shape is too light is to place your thumb over it and see if your eye moves through the painting, then move your thumb. Does your eye stop?

Pitcher: Use a soft blending brush to apply Phthalo Blue to the middle of the darkest values in the middle-upper area of the pitcher.

Lemonade: Finish up with a thin glaze of Ultramarine Blue and a delicate yellow glaze in the meat of the lemon slice.

Leaves: Place a cool Phthalo Blue glaze on areas of Alizarin Crimson to create dark edges. Veins will carry from leaf to leaf depending on the light source, so keep that in mind during these final touch ups. The veins of leaves will look different depending on the type of plant and how the light is hitting them.

When you have a complicated image calling out for you to paint, the thought of doing a minimum of seven thin glazes of colors per object can be daunting. When I photographed the setup, I knew I would need to establish three values on each shape. This is best accomplished first with transparent mixtures, then with individual color glazes. The transparent glazing technique can be used on anything that you wish to paint with luminosity. The backlit petals of a flower, a person's beautiful skin tones, or the sheen of old gray wood on the side of a barn.

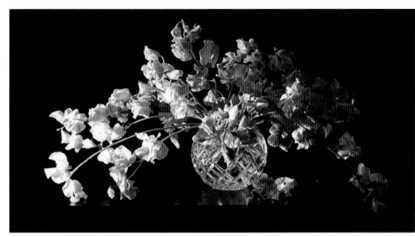

Reference Photo
The lighting used in this image was a 50-watt halogen spotlight shining from the left, with a dark mat board used as a backdrop.

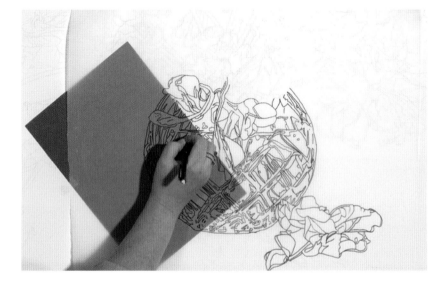

Transfer the Drawing
Draw just the shapes needed for the three strongest values: light (the white highlights), medium and dark. Once your drawing is complete transfer it to your canvas. See page 41 for tips on drawing and transferring your drawing.

When a drawing is this large and challenging, it helps to transfer it one section at a time so it's not so overwhelming. By drawing the crystal bowl on tracing paper, you can break down the transfer stage and see how and where it lines up on the canvas. This way you don't forget what areas you have transferred.

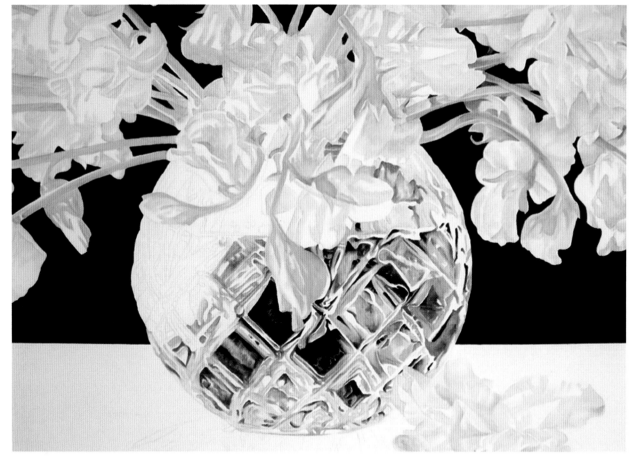

1 Glaze 1: Blocking In the Bowl

Before you begin blocking in the bowl, block in the background with a dark green mixture of Sap Green, Alizarin Crimson and Alizarin Blue Lake. See pages 38–39 for tips on blocking in the background.

When mixing transparent colors for the crystal bowl throughout this demo, you will often switch from a cool green to a warm green to an almost black, so prepare your colors before you paint. Your main focus while painting should be the edges and your placement of colors.

Painting one shape at a time is the best way to block in any complicated image. Think of each diamond shape in the crystal bowl or each petal as a tiny painting. Establish three values in each shape—light, medium and dark—then move on to the next shape. This is the path to realistic painting. When placing your three values, don't overlap the colors in a shape; simply lay them next to each other and blend the edges. If you need to smooth out your brush lines, do so with a soft blending brush and a delicate touch. Let dry overnight.

GLAZE 1 COLORS FOR THE CRYSTAL BOWL

Light green: Sap Green mixed with Indian Yellow

Light gray: Alizarin Blue Lake mixed with Quinacridone Red

Mid-value green: Sap Green mixed with Alizarin Blue Lake

Dark green: Sap Green mixed with Alizarin Blue Lake and Alizarin Crimson

—————— ✒ ——————

Don't Overload Your Brush

When placing more than one color in a small area the amount of paint on your brush is very important. If you can see a buildup of paint on your brush hairs you have too much. You're not after a finished value in these shapes. Plan to do a bit of blending for soft and hard edges, so you still have three distinct values.

—————— ✒ ——————

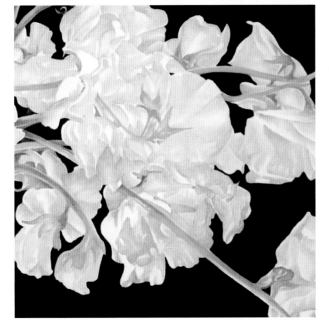

2 Glaze 1: Blocking In the Flowers

If you use only two color combinations for blocking in the sweet peas, use a deep pink for the darker shapes in the petals, then blend toward the middle-value areas. Use a light pink for the lightest pink area and blend the edge into the white highlight. This will total three values for the petals. Do this for each petal.

Blending is key in this step. When you blend edges, distinct value changes will show how each petal rolls. We're looking at the flowers on the right side because it helps to work on only one area at a time with a complex subject. Go through the same steps for the flowers on the left as well.

GLAZE 1 COLORS FOR THE FLOWERS

Sweet Peas: White highlights are the white of the canvas; the light source is from the left

Light pink: Rose Dore

Deeper pink: Rose Dore mixed with a touch of Quinacridone Red

Stem: Indian Yellow mixed with Alizarin Blue Lake

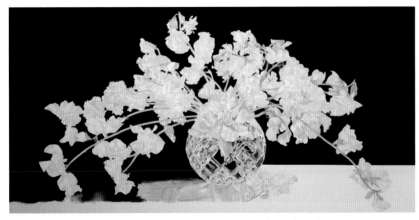

MIXED TRANSPARENT COLORS FOR THE REFLECTIONS

Background: Alizarin Crimson, Sap Green and Alizarin Blue Lake

Table reflections: Alizarin Crimson, Sap Green and Alizarin Blue Lake

3 Glaze 1: Blending the Background of the Table and Reflections

Paint the table after the background is dry and the crystal bowl and flowers have been blocked in.

The reflections in the table are the same mixture as the background, but mixed with more Alizarin Crimson.

The other colors are the same mixtures as the light pink on the sweet peas and the light green of the crystal bowl.

When doing a reflected section on the table, block in what you see, but keep the value of the color patterns light. If you don't like them, you can easily hide them in later glazes. Paint the dark reddish brown mixture near the reflected colors, allowing some room to blend and soften the edges into the reflected area. To keep from overlapping the dark reddish brown into your deep green background, use tape to keep the transition edge clean.

4 Glaze 1: Creating a Glow on the Table

Light and dark values and a few middle values give the table reflection its pop. Once you have applied your colors to the table, paint them in a pattern that is similar to what you see in your reference photo. Don't worry about being exact; you just want an impression of what you see. Blend some edges and keep a few hard ones. Keep it simple in these first applications to allow room for adjustment in later glazes.

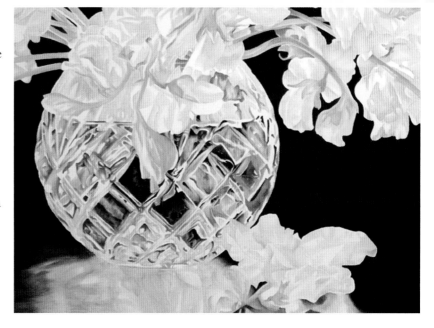

5 Glaze 1: Taping the Table Edge

When you divide up a table, there are different planes to paint. Each has different painting challenges, such as a texture that shows on one edge or plane, or a plane that is more reflective than the other. Plan to paint one section at a time. Pay close attention to the values on each and whether you need to cool or warm them, depending on how the light is hitting the table.

Use tape on the bottom and top edges of the table. The front edge will be painted last; that's why it's still white in this step.

6 Glaze 1: Bringing the Table Edge Forward

Once the first glaze is complete for the rest of the composition, remove the tape from the leading edge of the table. It's the closest part of the foreground and its value and color should be accurate when compared to the reflection area under the crystal. Make this table edge a warmer red-brown so that it moves forward. It will cool toward the edges of the painting, but with a strong enough contrast to pop from between the reflection and table edge.

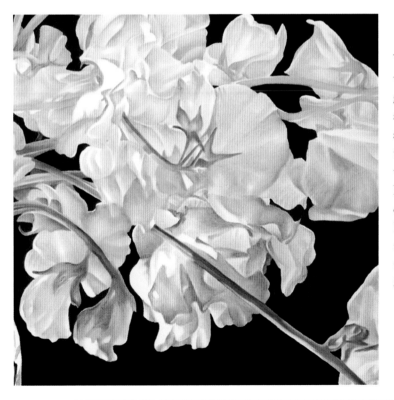

7 Glaze 2: Working With Each Petal

Add a second glaze to the sweet peas. When you start a new color glaze be sure to work it through each petal. Place a second glaze of Quinacridone Red on the darkest areas of each petal and blend. Be sure to keep some of the first glaze showing. The petals on the left side of the painting are lighter so there will be only a few places where Quinacridone Red is needed. When you have one color dominant in a flower, you only need to build layers of that same color or of a similar color in the same family. Here, you only need a glaze or two of cool blue for the shadows and a glaze of Sap Green on the stems. Let dry overnight.

8 Glaze 2: Concentrating on the Crystal Bowl's Values

This close-up of the crystal bowl is a good example of how crystal can change when light moves through it or when it is filled with water. The area above the waterline has different colors and values. Remember these as you block in your first and second glazes. Strong values are necessary for such differences in the object.

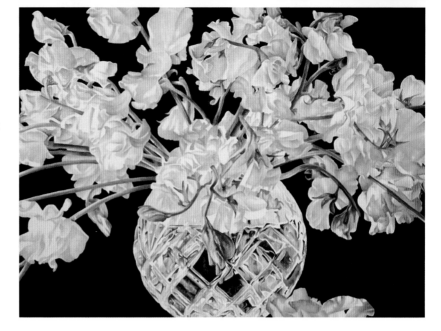

Arleta in Process With *Sweet Perfection*

Size matters. At least that is what the galleries tell me. As homes grow in size, so has the demand for large pieces of art. At this stage of the photo, I had already worked for a full month. About halfway though this painting I wondered why I had wanted so many sweet peas!

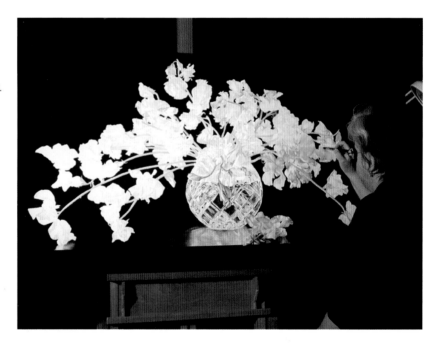

9 Glaze 2: Adding Tints to the Bowl and Reflection

Use Alizarin Blue Lake, Sap Green and a small filbert to tint the whites of
the crystal bowl. It may be hard to tint the precious white of the canvas that
you've worked so hard to save, but if you don't do it, the crystal looks like a road
map with white lines. I used a bright green, but depending on where and how the
light flows through your crystal composition, it may be a totally different color.

Keep the crystal bowl's reflection on the table simple so that you may add
more color or shapes in future glazes. Apply a few reflections, then use a mon-
goose to pull the paint across in a horizontal pattern. The reflections should
enhance the painting, not be the center of interest.

Tips for Realistic Crystal

Once you have established the dark and light patterns in crystal,
the white lines may appear too stark. With a small filbert, apply a
very thin glaze of each reflective color mixed with medium over the
lines to make the bowl look more complete. You may need to add
another tint after this dries for the lines to achieve a nice value.

10 Glaze 3: Developing the Flowers

Add a glaze of Ultramarine Blue to cool the pink color in the shadow areas. Blend every glaze for a distinct value change. The transition between the first, second and third glazes should build the realistic roll of each petal. Note how this group of flowers develops over the next few glazes.

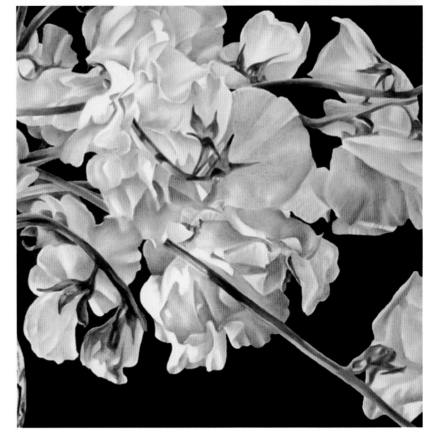

11 Glaze 3: Deepening the Colors of the Crystal Bowl

Deepen the colors in each segment of the crystal. It's difficult to blend in these tiny areas; use a smaller blending brush such as a flat sable so that you don't pull your paint too far or completely cover your previous glazes. This type of brush is useful for softening edges.

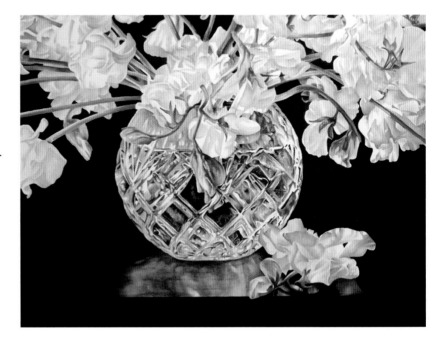

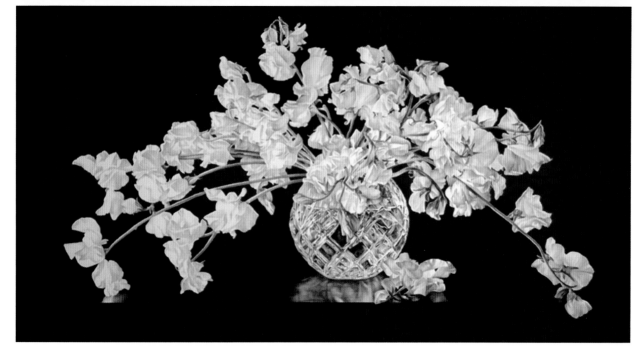

12 ***Glaze 3: Documenting Your Progress***
By building up the entire painting glaze by glaze you can see how the values stay in balance and relate to each other. This is how I taught myself to see and understand val-ues. Don't forget to take pictures of your works in progress to study later. (See pages 20–22 on photographing your artwork.)

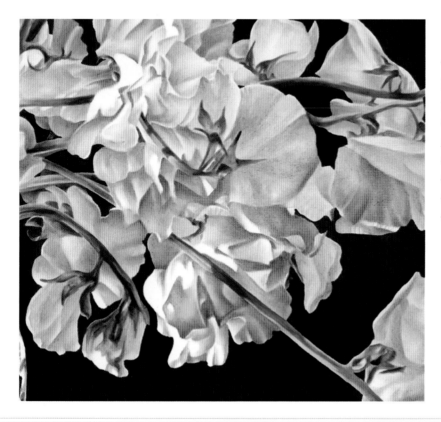

13 ***Glaze 4: Darkening the Flowers***

This fourth glaze of Quinacridone Red will really add value to the darker parts of the petals and create harder edges and cast shadows. Place a pure glaze of Alizarin Crimson on the stems of the sweet peas to darken the previous green glazes. The complementary colors will draw the eye to the red tint, creating color harmony.

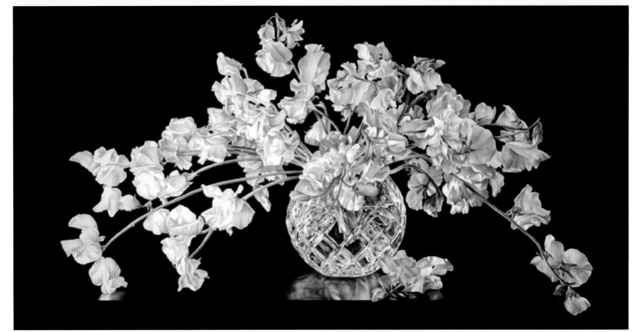

14 Glaze 5: Assessing Your Painting

Sometimes we can get lost while painting a large, complex subject. If you feel you have painted a shape too many times and it seems overdone compared to its surrounding petals, try this: Take a digital photo of your painting and compare it on your computer to the reference photo. You can also print out a copy of the photo of your painting in progress and compare its values to a printout of your reference photo to see if you're on track. Another thing you can try is to look at your painting in a mirror. Viewing the image in black and white or backwards will help you see where you should continue building values and where you should stop.

15 Glaze 5: Using Staining Colors on the Flowers

When you are working with a flower or object that has one dominant color, select several colors in that one color family to help you achieve the value you want. Here we have used Rose Dore in the first glaze, Quinacridone Red in the second through fourth glazes and now Alizarin Crimson—all in the red family. The first two colors are transparent while Alizarin Crimson is a staining transparent, which will help deepen the value of the petals. The fifth glaze is a good time to shift over to staining colors.

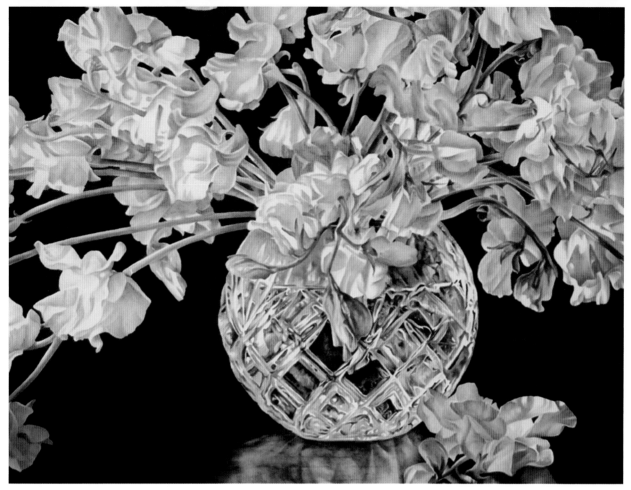

16 Glaze 5: Brightening the Crystal Bowl With Touches of Reflected Color

Now that the values in the crystal are close to finished, add some colorful reflections in the glass. The pink of the flowers makes a fun glaze, so use the same colors that were used to paint the flowers in the earlier glazes—Alizarin Blue Lake and Rose Dore—to brighten the crystal bowl.

Repeat a Subject's Colors for Its Reflections

When adding reflections to your painting, use the same colors as your subject to create color harmony. Adding a new color will pull the eye out of the painting.

17 Glaze 5: Blending the Reflection's Edges

Unless the reflection you are depicting is a smooth mirrored surface, its edges should be blurry and irregular, depending on the texture of the surface. Achieve this look by blending soft edges. The values of the reflection should always be a bit darker than the actual object.

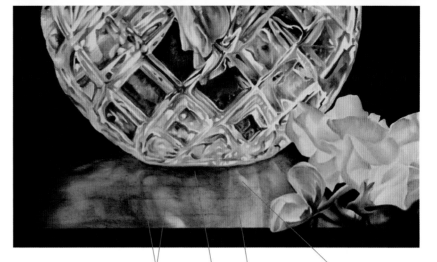

Drybrush horizontal lines
in the dark table mixture to
break up the reflection shapes

Dark shadow anchors
bowl to table

Soft edge highlight Hard edge highlight

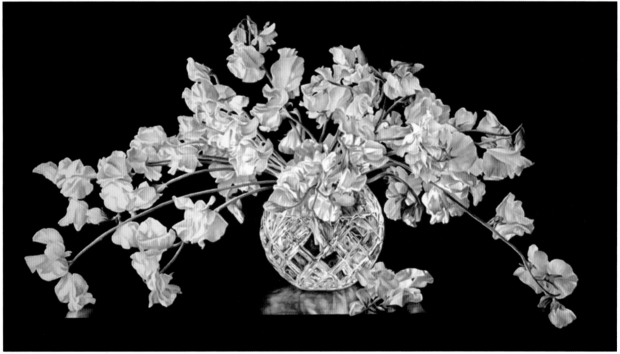

18 Glaze 6: Blending Flowers With the Background

Glaze the background color over some of the stems and petals to create soft edges that fade together. In this step the stems were darkened. At this stage, move the painting into another room to view it in a different light. Evaluate the painting. Are any values off? Incorrect shapes? Wrong colors? Messy edges? If your eye stops on an area, it probably needs to be fixed.

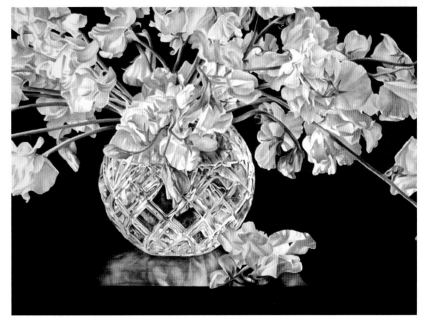

Close-Up of the Finished Crystal Bowl
Many times, the final touches in a transparent painting are small, dark shapes. They help add a last little pop that makes the painting sing.

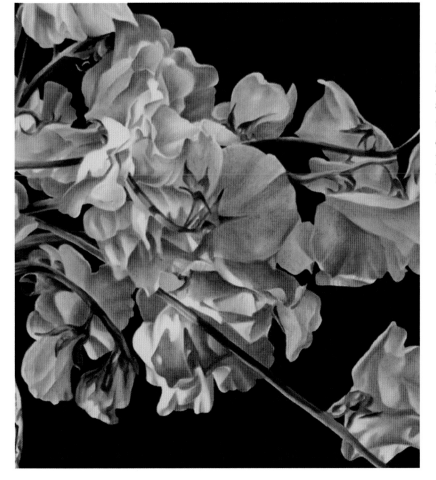

19 *Glaze 7: Adding Depth to the Flowers*

Place a glaze of Alizarin Crimson on the petals, if needed. Also place a light glaze of Alizarin Blue Lake on the stems. At this stage of the painting, use glazes to tuck petals under each other to add depth to your flowers. Reinforce the cast shadow edges and blend for smooth transitions.

20 Glaze 7: Accenting the Center of Interest

The lights and darks on the right side of the bowl have strong whites in the darkest petals that pull in the eye. White dominates the petals to the left of the bowl due to the strong light source. Because those flowers are less detailed, the eye is able to move through the painting back toward the center of interest: the luminous crystal bowl full of details for the eye to enjoy.

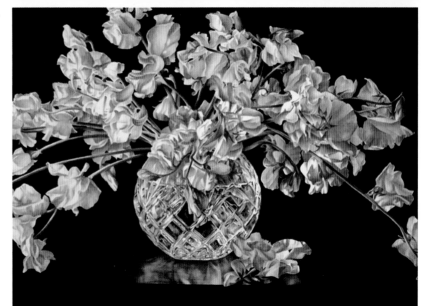

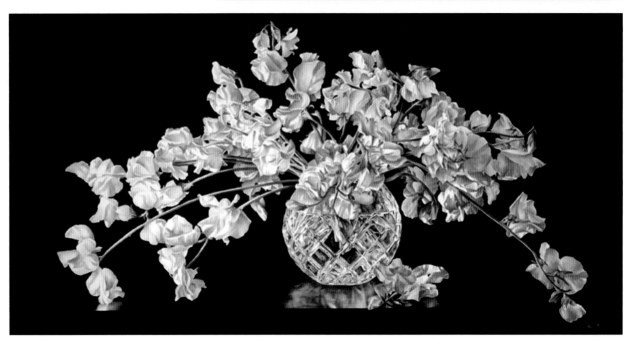

21 Glaze 7: Reassessing the Flowers

After the painting was nearly finished, I placed it in another room and let it dry for a month. Giving my eyes such a good rest helped me judge the painting with a fresh perspective. After a month, I pulled it back out and decided that the values needed to be deeper in some areas. I added a glaze of Quinacridone Red mixed with Alizarin Crimson over the rear petals in shadow.

Store Your Paint for the Long Term

I don't store my glaze mixtures because the medium gets tacky, but I do freeze unused globs of paint. Since I use most of my colors straight from the tube and thin them down with medium, I start my palette fresh every day.

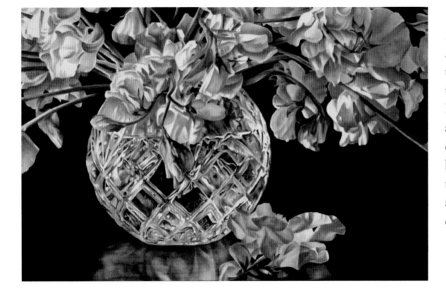

22 Glaze 8: Leading the Viewer's Eye

After glazing the petals, I darkened the light values of the crystal bowl on the lower left area with a soft Alizarin Blue Lake glaze near the table; only a few whites remained on the outer edge of the bowl. At this stage, decide how you want to lead your viewer's eye through your painting and then make adjustments toward creating this trail of light.

23 Glaze 9: Making Final Adjustments

Squint at the image and decide if you need any more glazes. I was looking for one more pop of contrast, so I decided on one last glaze of Alizarin Blue Lake on a few of the petals. It's easy to lose track of the number of glazes you've completed. Keep in mind that the last few glazes are final adjustments and should be placed only on selected areas, not the entire painting.

Plan the Center of Interest

When planning the center of interest in a painting, ask yourself where you want the eye to return after looking at all the elements. Are you directing the eye to a complicated area, or where the shapes and patterns have interest and variety? A good center of interest can be where the lightest light sets against the darkest dark.

final Alizarin Blue Lake glazes

Sweet Perfection ❧ 32" × 60" (81cm × 152cm)
Oil on canvas ❧ Collection of the artist

Final Thoughts
Creating a beautiful painting is fun and exciting.
Every painting is a quest for our best at that moment
in time. There is always a time to stop and let a paint-
ing be, even if you think there is more to achieve.
Though the light in this complex painting eluded me

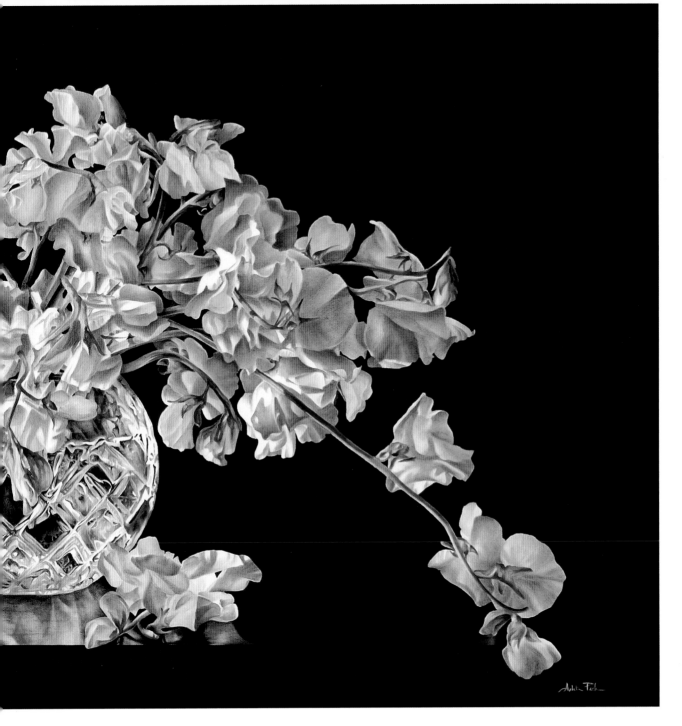

a bit, it was the light that drew me to the image in the first place.

When I struggle to capture the light in a painting such as this one, it helps to keep in mind the following guidelines: In the lightest petals strive to paint about 20 percent of the petal, leaving the rest white; cover about 60 percent for the midvalue petals; and about 90 percent for the darkest values. These are just loose numbers, though. Learn to train your eyes to judge where the values change. That's the key to good painting in any medium.

Painting sheer curtains or dresses, or any material where the light passes through, is a great exercise for painting values. Painting the soft folds of sheer material and cascades of lace is not so different from the subjects we've learned so far. When painting lace or fabric, I prefer to develop the material before painting any details, patterns or lace holes. Creating the roll of the folds is simply the first step. Each shape in this type of material has a gradation of values, just as in *Sheer Perfection*. Pay close attention to how the light hits the background and the objects. The subtle value changes are what you trying to describe with your paint.

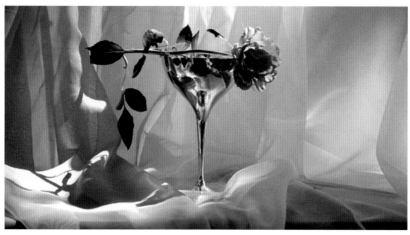

Reference Photo

Draw Your Reference Freehand Using the Grid Method

I drew my reference freehand on the canvas instead of transferring it with graphite transfer paper. Create 1-inch (3cm) squares directly on your photo using a ruler and a fine marker. Using a light gray pastel pencil, indicate the same number of squares on your canvas or board at a 2-, 3-, 4-inch (5cm, 8cm, 9cm) or larger size in proportion to the photo. You should have the same number of squares on your photo reference as on the canvas. Lightly draw what you see in each square on your canvas with a pastel pencil.

1 Glaze 1: Starting With the First Glaze of the Sheer Background and Flower

When you have a large area of delicate values, it's good to be consistent and stick to one color for the first background glaze. That way you need only focus on creating the roll of each shape. On your palette, create a grayed mixture of Ultramarine Blue and a touch of Burnt Sienna. Lighten it with a touch of medium to create a workable mixture and paint each shape of the background material. When the rolls of material look right, blend out any streaks with a soft blending mop.

Silver is challenging because it reflects all of its surrounding colors. There is no set formula for painting silver. Paint each shape reflected in the silver the same way you would paint the folds of the material—with a gradation of values. In this first glaze, the blue of the material alters the color of the silver, so establish the value of the silver cup with a dark version of this background mixture, and a lighter version of the mixture in the body of the cup. Also reflect the colors of the rose in the silver cup area.

The lightest area of the flower's leaves is a bright yellow-green, so glaze Transparent Yellow for the flower's base value. A second glaze of blue will give the leaves a bright green glow. The same blue on top of Indian Yellow would yield a much warmer green. Warm or cool, it's up to you, just make sure each leaf is kept consistent.

GLAZE 1 COLORS

Sheer material: Ultramarine Blue with Burnt Sienna

Silver cup: Ultramarine Blue (Green Shade) and Burnt Sienna

Silver cup's dark reflections: Gray mixture of Ultramarine Blue, Quinacridone Red and Transparent Yellow

Rose: Quinacridone Red

Leaves: Transparent Yellow

Close-Up of Flower and Cup Reflections

Using a safe gray mixture of Ultramarine Blue (Green Shade) with Burnt Sienna for the deepest grays will allow you to continue glazing luminous colors on top of a dark value.

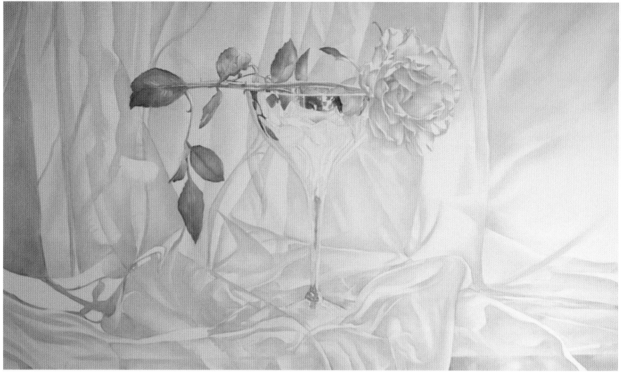

2 Glaze 2: Building Color and Values

In this second glaze, retain most of the light value folds from glaze 1—this is the key to capturing the sheer look. If you go too dark too fast you will lose the subtle value difference between folds. You can always go back and tint a shape or adjust its value in a later glazing stage.

Use the same thin blue mixture across each sheer background shape, even though the reference photo shows the material as a deeper blue on the left side. Use the same value throughout each glaze; the value will darken naturally through layering. Blend the paint to create a lighter value structure of the material.

On the rose, a yellow glaze over the pink from the first glaze creates a lovely peach value. Cover most of the first glaze and thinly blend, including the reflections in the cup, allowing a bit of Quinacridone Red to peek out of the top left petal edges. Never paint a glaze so thick that you prevent the previous color from showing through.

Strengthen the dark area of the leaves to a deep green by glazing a bluish green mixture. Make sure to leave plenty of the cool yellow showing. Gradually, the leaf color will build to a bright green.

GLAZE 2 COLORS

Sheer material: Mixture of Ultramarine Blue, Burnt Sienna and a touch of Alizarin Blue Lake

Leaves: Mixture of Alizarin Blue Lake and Indian Yellow

Rose petals and reflection: Indian Yellow

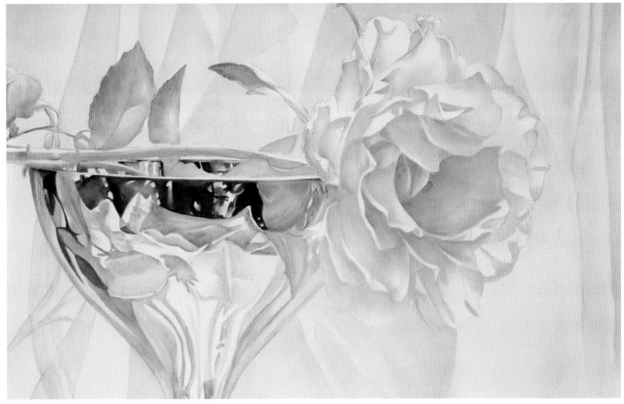

3 Glaze 3: Painting Dark Tones on the Flower's Center and the Silver Cup

Apply a third glaze of Quinacridone Red to the center of the rose to bring out a deeper pink tone. Also glaze the flower's reflection in the cup as well as a few of the inner petals to form the curving center of the blossom.

When painting silver, as opposed to sheer or transparent objects, the dark values must be painted early in the glazing process to create the proper contrast between the background and subject. Repeat the blue value of the sheer background's first glaze to darken the background reflections in the silver cup.

The dark grays from the first glaze must go much darker. Use three colors to make black: Alizarin Crimson, Alizarin Blue Lake and Sap Green (see page 37 in chapter 4 for more on mixing black). Always place your darks for silver after the first glaze is dry to establish a strong value contrast that creates shine. After this glaze, leave the black area alone until the rest of the painting values are in balance. You can adjust the dark grays in the final tweaking stage.

GLAZE 3 COLORS

Silver cup dark tones: A black mixture of Alizarin Crimson, Sap Green and Alizarin Blue Lake

Rose center and reflection: Quinacridone Red

Leaf reflection: Alizarin Blue Lake and Indian Yellow

Tips for Painting Silver

When adding values to silver and its reflections, look closely for tiny, individual shapes. Silver reflects whatever is nearest to it. Many times, the reflections you are depicting are actually your self-portrait because your image is reflected when you snap the reference photo. It's OK to make adjustments to take yourself out of the painting. Also, avoid brightly colored shirts when photographing your silver compositions.

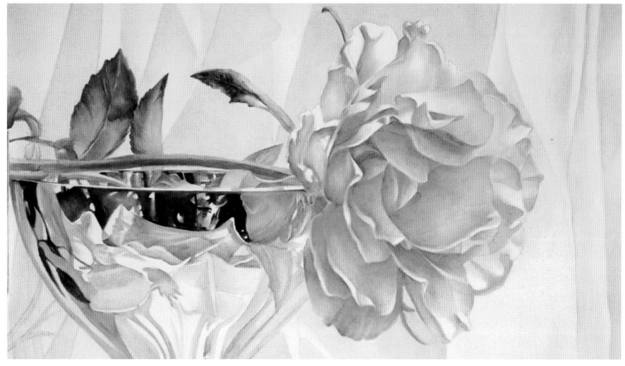

4 Glaze 3: Deepening the Values of the Rose

Complete another glaze of Quinacridone Red on the rose petals and deepen the values of the leaves and stems. If you don't get too dark, the leaves should really start to pop. But if you have trouble judging values, then apply just a thin glaze building layer by layer—it's a much safer process.

GLAZE 3 COLORS
Leaves and stem: Mixture of Alizarin Blue Lake and Indian Yellow
Rose petals: Quinacridone Red

Background or Subject or Both?

This painting is unique because it feels like the sheer material is both subject and background. For this reason, I bounced back and forth between the sheer material and the goblet and flower instead of completing the third background glaze all at once after the third glaze of the cup, flower and leaves.

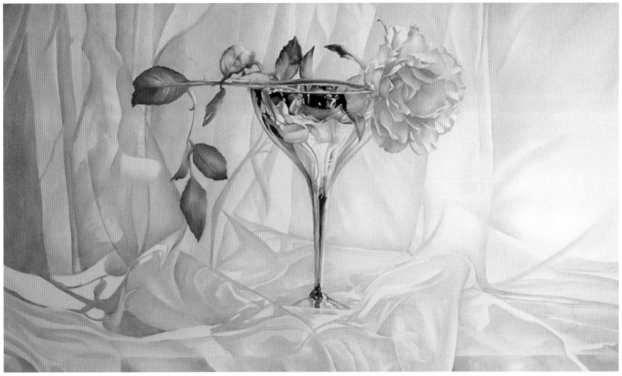

5 *Glaze 3: Creating Gradation in the Background*
When painting a complex, sheer material, start on the darkest side of the background and move across toward the light. Add glazing medium to the background value to lighten the mixture as you go.

Pay attention to the edges of the folds on each glaze. You want to avoid hard edges. Keep the glazes soft and flowing by blending with a soft mop.

GLAZE 3 COLORS
Sheer material: Mixture of Ultramarine Blue, Burnt Sienna and a touch of Alizarin Blue Lake; add medium and blend to lighten

Close-Up of the Reflection After the Third Glaze
The value changes on reflections are subtle, but slowly changing with each glaze. Have fun selecting your glazing colors. Sometimes you must forget the reference photo and make an edge darker or lighter, depending on how your painting is developing. This becomes easier to judge with practice. Here, the values of the edges of the silver goblet and the background material are very close, so I glazed the goblet a bit darker with Alizarin Blue Lake to help it move forward.

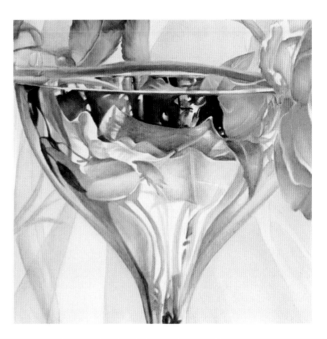

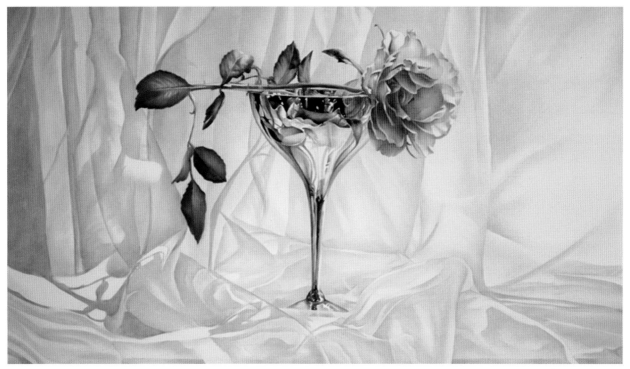

6 *Glaze 4: Adding Variety to the Rose*
Glaze the rose petals with a mixture of Alizarin Crimson and Indian Yellow. Avoid painting the ends or folds of the petals and focus just on the crevices. Keep a gradation of values so the petals turn or tuck behind each other. Deepen the leaves with a glaze of green.

GLAZE 4 COLORS
Rose petals: Mixture of Alizarin Crimson and Indian Yellow

Leaves: Alizarin Blue Lake, Indian Yellow and a touch of Alizarin Crimson

Close-Up of the Leaves' Fourth Glaze
Leaves are fun to paint and add great value variety to any floral painting. Each half of a leaf should be a different value pattern. One side should be more detailed and light, the other less detailed and in shadow. Use the center vein as the bridge that lets you compare the other side for the differences.

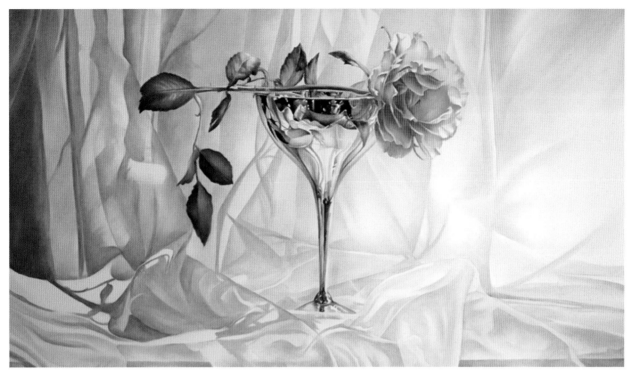

7 *Glaze 4: Fixing the Awkward Stage*

Every painting has an awkward stage, even for artists with years of experience. This usually refers to balancing values. Here we need to deepen the values of the background and balance them against the lighter right side. Working from dark to light is the best way to balance the values in a painting.

Deepen the left background glaze with the same mixture as glaze 3. Add medium and blend to lighten on the right side. Take your time. Let dry and repeat if you are not satisfied with the dark and light balance of the material.

GLAZE 4 COLORS
Sheer material: Mixture of Ultramarine Blue, Burnt Sienna and a touch of Alizarin Blue Lake; add medium and blend to lighten

Tip for Checking Your Values

Take a digital photo of your painting in its awkward phase and load it into a simple editing software program on your computer. Change the photo to black and white and compare your darks and lights. Then compare this to the color photo and you will easily see where your values need to be adjusted.

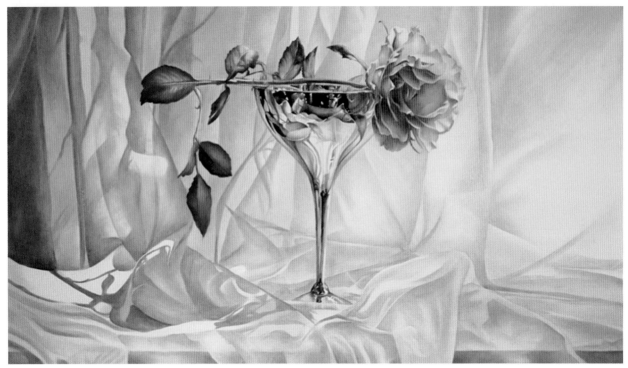

8 *Glaze 4: Make Value Adjustments to the Background*

I made value adjustments in the midvalue areas of the background behind the leaves and where material folds tuck under one another. Often when I have trouble balancing my values, it's because my middle or dark values are not deep enough. When your lightest values need adjusting, that means your entire painting is a little off.

Balance Is the Key to Realistic Painting

Strive for an artistic representation of the reference photo, not an exact copy. Balancing your values overall is the key to transparent glazing. The same goes for petals, leaves and flowers. Keep them a bit lighter than the reference photo so they don't look like colorful holes on the canvas. Reference photos are only a jumping-off point. Train your eyes and artistic senses to decide how to edit and change your paintings.

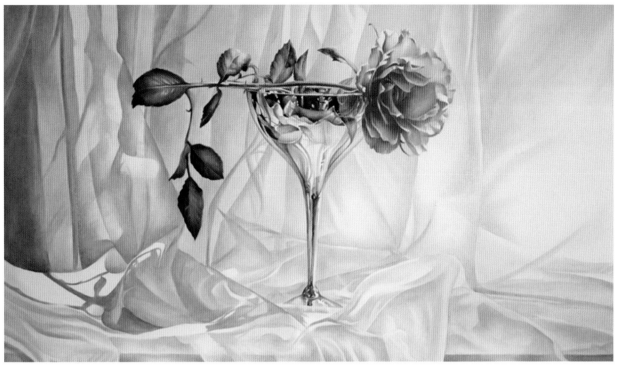

9 Glaze 5: *Lightening the Background on the Right*

To lighten the right side of the background material, glaze over the area with a mixture of Quinacridone Red, Indian Yellow and a lot of medium. Though the tinted value glaze is subtle, it will brighten the lighter side of the material with a warm glow. The most delicate glazes should be made toward the end of the painting so they don't get lost under other layers.

Paint a glaze of Alizarin Crimson mixed with a touch of Sap Green over the dark crevices of the rose petals. Be careful not to pull the deepest colors too far out onto the ends of the petals.

GLAZE 5 COLORS
Sheer material (right side): Mixture of Quinacridone Red, Indian Yellow and medium

Rose petals: Alizarin Crimson with Sap Green

10 Glaze 5: *Assessing the Painting*

As you get close to finishing the painting, place it in another room or under different lighting. Decide if everything looks good or if it needs any other value or color adjustments. Keep the deep value center of the rose a bit lighter than the reference photo so that it doesn't look like a dark orange hole in the canvas.

Sheer Reflections 🍃 28" × 48" (71cm × 122cm)
Oil on canvas 🍃 Collection of the artist

11 *Glaze 6: Touching Up the Background with an Opaque Mixture*
After evaluating the painting, I decided it needed more of a gauzy feel.
I created a thin, milky mixture of Titanium White and a touch of Ultramarine
Blue and Burnt Sienna. I glazed it over the entire background of sheer material.
It's fine to use opaque colors in moderation toward the end of a painting. You are
the artist, and you must do what's right for the painting.

Final Thoughts on Folds and Shadows

Subtle values are key with sheer materials, so take your time to build each glaze. Even in this painting there were areas where I struggled to create strong value transitions. The *range* of values is most important when creating sheer material.

Placing Glazes in Unique Lighting

In chapter one we talked about taking reference photos to show off your compositions in the best possible light. In this demonstration we'll discuss how lighting and the placement of your glazes will help you lead the viewer's eye through the painting and to the areas where you want the viewer to pay close attention. As you work through the demonstration, think about the colors you will choose for each glaze, and how the order of their placement will make a difference in the value outcome. Each step is accompanied by a diagram outlining the exact areas to place each glaze, so you can learn to think about value coverage in a new way.

Materials list

colors
Alizarin Blue Lake
Alizarin Crimson
Indian Yellow
Permanent Rose
Quinacridone Red
Sap Green
Ultramarine Blue (Green Shade)

brushes
various sizes of filberts, flats, mops and scrubbers (see page 11)

medium
select a medium that works well with your brand and type of oil paint (see chart on page 15)

tools
pastel pencil

palette knife

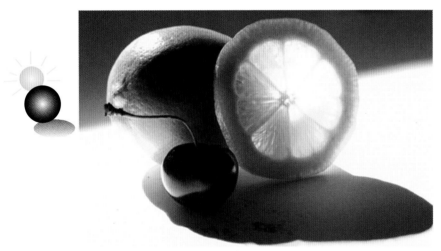

Reference Photo: Lit From Behind

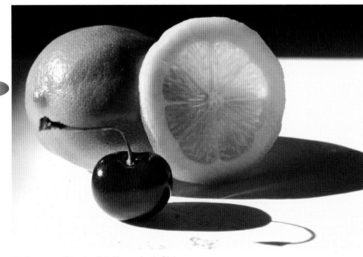

Reference Photo: Lit From Left Side

Reference Photos

Light plays an important role in every painting. Each of these *Lemon-Lime Soda* studies was photographed from a different angle of light: The top photo is backlit and the bottom image is lit from the left side. Both light sources were from the sun, and I arranged the compositions by moving the objects around in the light. The placement of the fruit in each study is almost identical. My camera captured objects and shadows exactly as I wanted them in each moment in time.

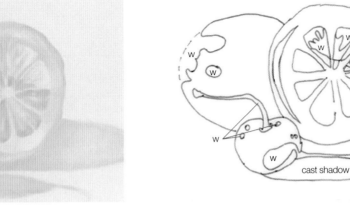

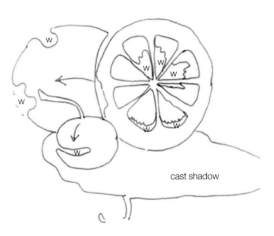

1 Glaze 1: Applying the Base Colors

Take note of the difference in the cast shadows, especially for the cherry stem. The light can easily alter the look of an object and cast a shadow off in another direction. If capturing a light source just so is important to you, snap reference photos to freeze the march of the sun. The only way to keep light from moving in a composition setup is to use artificial light, such as a spotlight.

Diagram: Glaze 1

Some of my students find value diagrams helpful because they can see approximately how much each glaze covers the canvas. Everything gets a glaze except the white highlights marked with a W. The diagram for glaze 2 will indicate where and how much area to cover.

GLAZE 1 COLORS

Limes: Sap Green on both limes

Lemons: Indian Yellow on both lemons

Cherries: Alizarin Crimson on the top cherry; Permanent Rose on the bottom cherry

Cast shadows: Indian Yellow on both

2 Glaze 2: Building the Colors

In the reference photos, the top cherry is much darker, almost black, compared to the rosy bottom cherry. Start with a deeper paint color to build the value faster. The base of the top lemon's rind is red, and the rest is a grayed shadow. It takes three primaries to get a gray, so it will take a few more glazes. Glaze the background with a dark green mixture. Let it dry for at least half a day and the background is complete.

GLAZE 2 COLORS

Limes: Alizarin Blue Lake on both; Indian Yellow on the bottom to warm the green on the edges

Lemons: Thin glazes of Indian Yellow at the base of both lemon rinds; Quinacridone Red at the base of the top lemon's rind

Cherries: Alizarin Blue Lake on the top cherry, Permanent Rose on the bottom cherry

Background: Sap Green, Alizarin Blue Lake and Alizarin Crimson

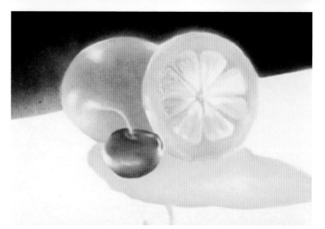

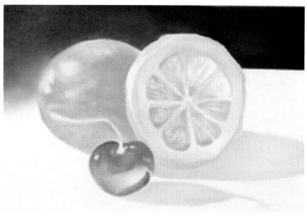

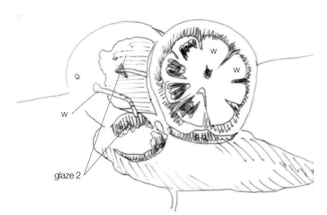

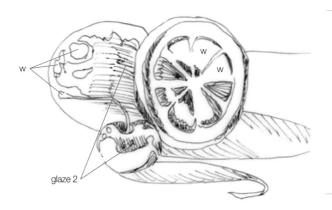

glaze 2

glaze 2

Diagram: Glaze 2

The dark areas are where the values need to be deepened. The tips of the cherries and light flesh areas of the lemons must be preserved. When you are painting two similar but uniquely lit compositions, study the differences before you glaze.

Don't Overdo It!

One of the tendencies of newcomers to transparent glazing is to cover too much of the object in each glaze. A glaze may be small and only cover a certain area of an object, or be made up of two or more tiny glazed shapes, or be one large glaze. There will be more glazes to apply after this second one to adjust values and change hues, so take it easy early on.

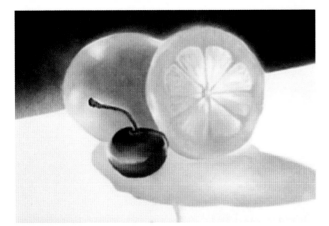

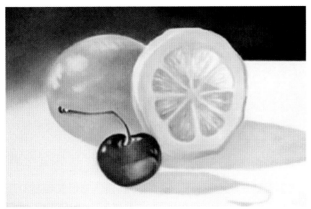

3 *Glaze 3: Adding a Bit of Accent Color*

Apply a glaze of Quinacridone Red to the top lemon's backlit cast shadow, but leave a bit of yellow showing in the shadow's center to reflect the lemon.

Keep the bottom lemon soft and light in value by glazing Ultramarine Blue in a few areas of the rind and Sap Green in the flesh of the lemon.

For the top cherry, glaze a red value on the blue of the cherry's top to get a cool violet value. Do the same thing on the bottom cherry behind the stem, but in a smaller area.

Alizarin Crimson, a complementary value of green, will deepen the values of the limes. Glaze more red on the top lime because it is in shadow, and less on the bottom lime to keep the green value light.

GLAZE 3 COLORS

Limes: Alizarin Crimson on both

Lemons: Quinacridone Red on the top lemon; Ultramarine Blue and Sap Green on the bottom lemon

Cherries: Alizarin Crimson for both

Cast shadows: Alizarin Crimson for both

Diagram: Glaze 3

Glaze 3 is all about shimmer and involves limited glazing on select areas. Use the diagram to visualize where and how much area each glaze should cover.

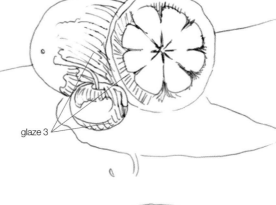

glaze 3

glaze 3

4 Glaze 4: Bringing Out Colors in Cast Shadows

This stage is when the values really start to build. I love the shimmer colors showing through the layers of paint. The cast shadow on the top looks like a kaleidoscope. Place two of your strongest colors—Alizarin Blue Lake and Alizarin Crimson—in this cast shadow glaze and blend. This creates the multicolor look and anchors the cherry to the table. Place a light glaze of Sap Green on the top lemon's rind and the strings of pith separating the eight slices of fruit. Glaze the meat of both lemons with Ultramarine Blue and Indian Yellow.

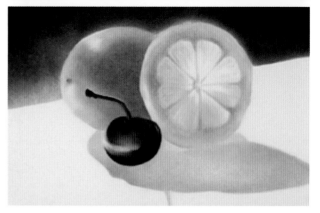

GLAZE 4 COLORS

Limes: Sap Green on both

Lemons: Sap Green on the top lemon rind and pith; Ultramarine Blue and Indian Yellow in the meat of both lemons

Cherries: Alizarin Blue Lake on the top cherry's dark areas; Alizarin Crimson to deepen the red in both

Cast shadows: Alizarin Blue Lake and Alizarin Crimson

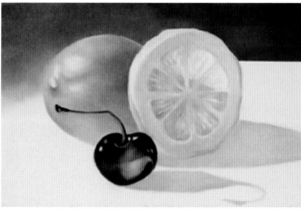

Diagram: Glaze 4

This glaze focuses on honing the round form of the fruit and deepening the shadows, but only where the diagram shows the darkest areas.

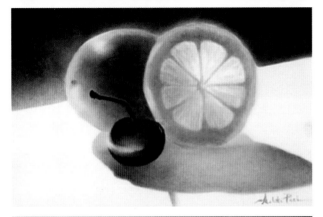

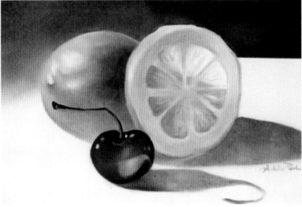

5 Glaze 5: Adding Dramatic Details

This last glaze pulls it all together: It deepens the drama of the backlit image, and spotlights the cherry on the normal light image. Each has its appeal, but I love the drama of the backlit study.

Glaze Sap Green mixed with Alizarin Blue Lake on the limes. On the bottom lime, all the previous glazes still show, so use this glaze to unite the layers. Also decide if you want to tint any of the white shapes.

Use Indian Yellow to add warmth to the rind and meat of both lemons.

Brighten and warm the cherries with Quinacridone Red. I also used the color to tint the white highlights. Glaze Alizarin Blue Lake into the bottom cast shadow to cool the shadow tones. In the top shadow, apply the blue glaze only under the cherry and tint the shadow green near the lemon and deeper gray on the right side.

GLAZE 5 COLORS

Limes: Sap Green mixed with Alizarin Blue Lake on both

Lemons: Indian Yellow on both

Cherries: Quinacridone Red on both

Cast shadows: Alizarin Blue Lake

Diagram: Glaze 5

Evaluate what your painting needs for the final glaze. Sometimes it helps to glaze a large section, such as the outside of the top lemon and the meat of the lower lemon.

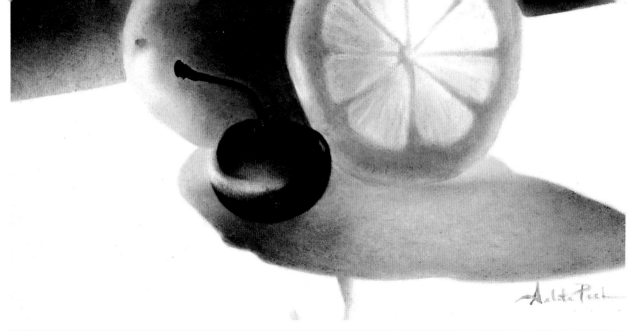

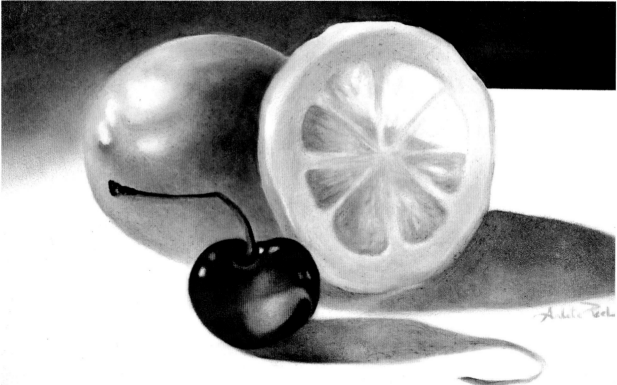

Lemon-Lime Soda ✦ 9" × 12" (23cm × 30cm)
Oil on board ✦ Collection of the artist

Final Thoughts on Lemon-Lime Studies
This is the first time I painted the same composition with different light sources simultaneously. It is very rewarding to see how the value glazes describe the light. Try a setup of your own in two different light sources. Don't move the objects around, just alter the light.

Evaluate Your Painting

Always take a moment to evaluate your painting from a new angle or light. If you notice an area that doesn't look quite right, ask yourself a few basic questions about the shapes, values and edges.

Problem	Solution
Is a shape that doesn't look quite right perhaps drawn badly or fighting for attention with its subject?	Correct this by painting the area around that shape.
Is the value of the problem area too light or too dark for the rest of the painting?	Squint at the painting, or move it into a different light. Adjust values accordingly.
I used the wrong color in an area of my painting.	Using a color different from the painting's original palette will make it stand out. Use it in at least three more areas to help it look less foreign.
I have too much of one kind of edge throughout the painting.	Soften hard edges as needed with a mop brush. Clean up your hard edges near the focal point. Try to strike a balance. Too many hard edges and your painting will look like a road map; too many soft edges and you eliminate the center of interest.

Too Many Hard Edges in the Background Detract From the Subject

I had the idea of doing a light value checkerboard background, but as I continued to work on it, it didn't work with the complicated subject. The excess of hard edges of the checkerboard pulled the eye away from the teapot, clock and rose. To fix this problem, I repainted the background a solid dark color to make the subject pop.

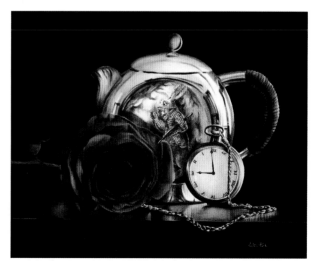

Timeless ❧ 16" × 20" (41cm × 51cm)
Oil on canvas

125

Glazing Techniques in Action

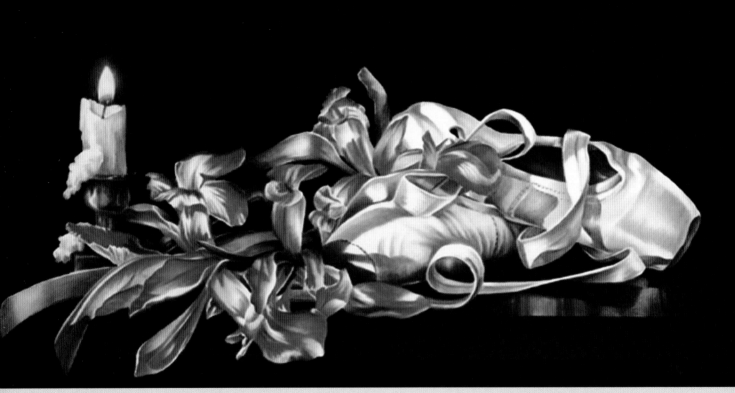

Ashley's Ballet ✦ 10" × 20" (25cm × 51cm)
Oil on board ✦ Private collection

Photographing a Flame
I backlit this wild iris scene with a 50-watt spotlight to enhance the candlelight's warmth and to create stronger cast shadows. The key to painting a flame is distinguishing the darks and lights; that's how you show the burn. The balance of warm and cool tones also tells us that it a flame.

MY ART CAREER SPANS OVER FORTY YEARS, AND IT IS amimazing to see how I have grown as an artist as I look back over my body of work. I'm hopeful you will use this gallery to learn, grow and become inspired. These pieces are a combination of all of my years of practice. I strive to create paintings on three levels: artistically, emotionally and intellectually. As you continue to grow as an artist, strive to make each painting better than the last.

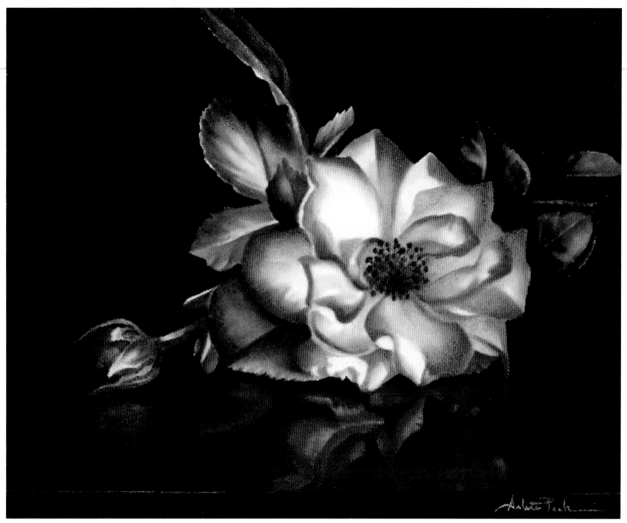

Betty Boop Delights ✎ 9" × 7½" (23cm × 19cm)
Oil on board ✎ Private collection

Creating Reflection

I photographed this Betty Boop rose inside a three-sided box painted black in natural sunlight from a south window. I used furniture oil to shine the table for a dramatic reflection. The optical grays of the rose's petals near the center were glazed with the primary colors (see page 33).

Mixing Unique Subjects

The lace of my grandmother's hankercheif dresses up this Betty Boop rose as if it's ready for Sunday school.

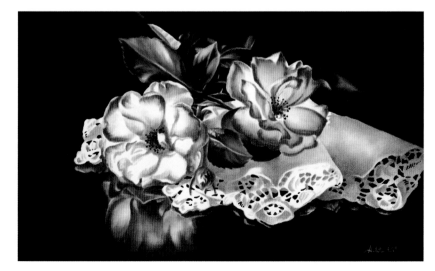

Sunday Best ✎ 8½" × 12" (22cm × 30cm)
Oil on board

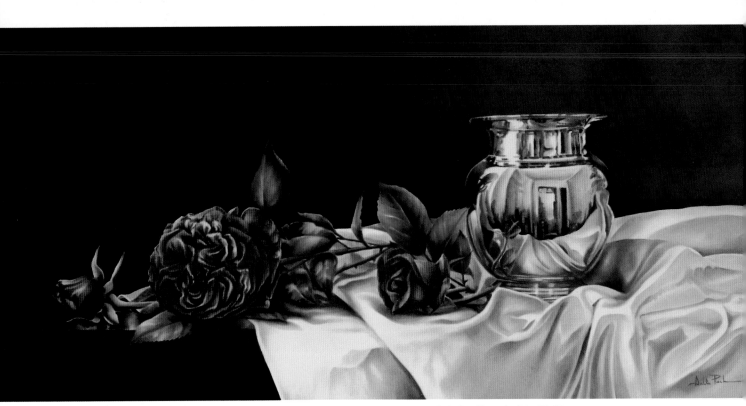

Elements of a Still Life ❧ 12" × 25" (30cm × 64cm)
Oil on board ❧ Collection of the artist

Read a Painting From Left to Right

From left to right, the objects in this painting go from small and dark (table and flowers) to large and light (silver and fabric). The center of interest is the large silver vase set against the painting's darkest dark. Vary the negative and positive space when setting up a composition. The space between objects should never be equal.

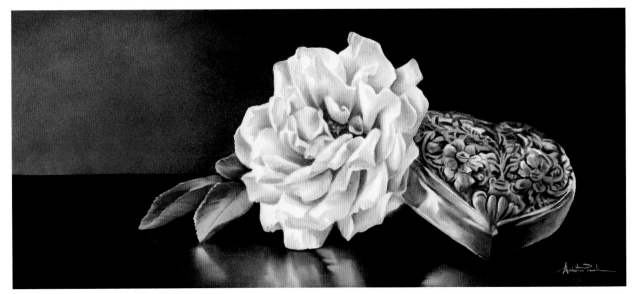

Heart's Desire ❧ 5" × 13" (13cm × 33cm)
Oil on board ❧ Collection of the artist

Build Details Slowly

I paired this sterling rose from my garden with a little silver heart from my studio. This composition was easier to paint in oil than watercolor. I built the details slowly to get a feel for the light, middle and dark glaze variations.

Using North Light

I photographed this scene about 3 feet (1m) from a north-facing window. The cool north light creates the glow on the table and keeps the values closer together. With this type of light, there are fewer white highlights; the highlights tend toward the middle range. North light is considered the most natural by many artists.

Peach Perfection ❧ 9" × 14" (23cm × 36cm)
Oil on board ❧ Collection of the artist

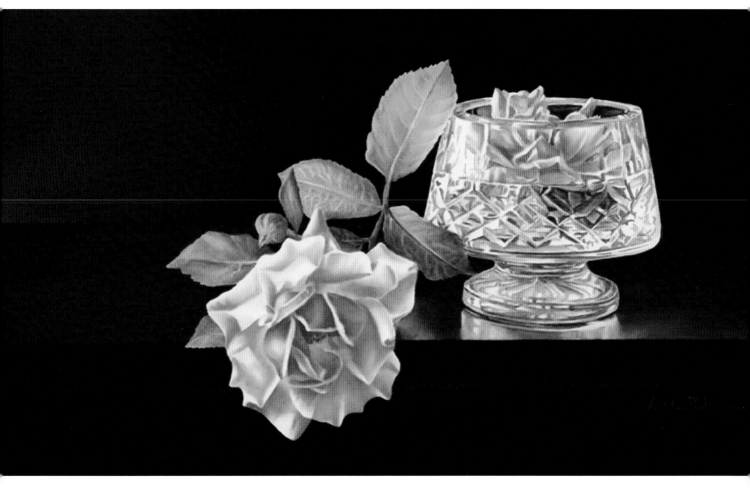

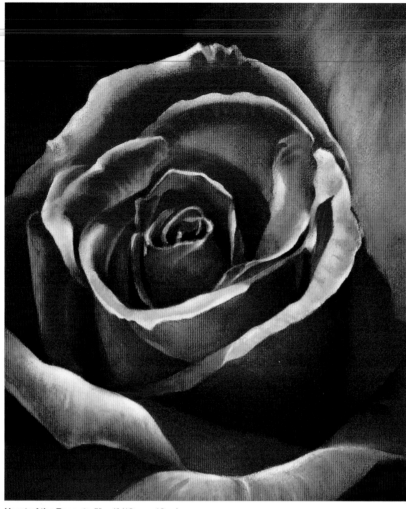

Capturing Red in Sunlight

This painting is small, just 5" × 4" (13cm × 10cm), but so powerful. It reminds me of when I started as an artist and loved to paint blossoms. I photographed this rose in a garden on an overcast, but sunny day. Red can be challenging to photograph because it either absorbs the light, thus eliminating casts, or it shows up orange in the highlight areas. I photographed this rose many times throughout the day until I captured just the right light. When painting just flowers, a variety of shapes and values helps keep the eye interested.

Heart of the Rose ❧ 5" × 4" (13cm × 10cm)
Oil on board ❧ Private collection

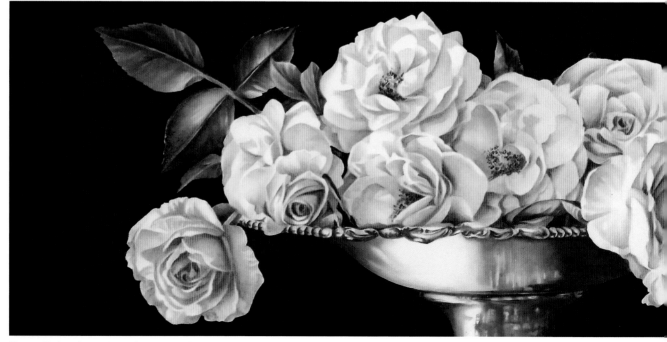

Up on a Pedestal ❧ 10" × 27" (25cm × 69cm)
Oil on board ❧ Private collection

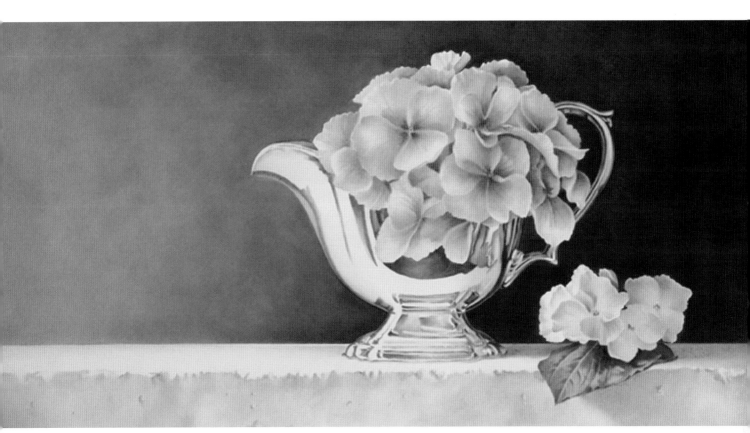

Limestone and Silver ❧ 13" × 27" (33cm × 69cm)
Oil on board ❧ Collection of Robert B. Simon, MD

Setting Up a High-Key Study

I used only north light for this study. This kept the delicate hydrangea blossoms from bleaching out. The light bouncing off the white limestone and into the silver made this a *high-key* painting—most of the image appears in light.

If this setup had been photographed in full sunlight, it would have been a washed-out image.

Manipulate the Composition to Help Direct the Viewer's Eye

I limited how much vase showed in the painting to make the pink roses the focal point.

131

Reflections ❧ 22" × 30" (56cm × 76cm)
Oil on board

Utilizing Different Lights

I arranged this composition inside my three-sided black box lit by a 50-watt spotlight. The angle of the spotlight helped light up the brass objects, while the candle added warmth to the rose. The lace is the white of the canvas with a few shadows glazed on; however, I did need to go back in with white paint to clean up some of my edges.

Red Satin and Peonies ✿ 25" × 19" (64cm × 48cm)
Oil on board ✿ Collection of the artist

Using the White of the Board
The delicate whites in this painting were created by the white of
the board. When working with whites, pay attention to the color
in the white's shadows (here, in the petals on the pitcher). Without
the subtle value differences, the painting would look washed out.
Similarly, this painting would look very different if the whites had been
painted opaquely.

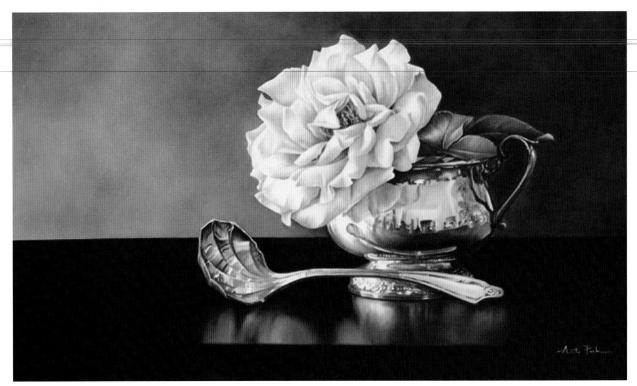

Simply Sterling ✿ 15" × 25" (38cm × 64cm)
Oil on board ✿ Collection of the artist

Emphasizing White Highlights

This composition was photographed in north light on a sunny day. This helped emphasize the white highlights in the rose. Silver picks up so many of its surrounding colors, creating a painting challenge of beautiful abstract shapes.

Create Subtle Shades by Glazing Complimentary Colors

Layered glazes of Permanent Rose and Ultramarine Blue (Green Shade) create the subtle purple shades within this pink and white Betty Boop rose.

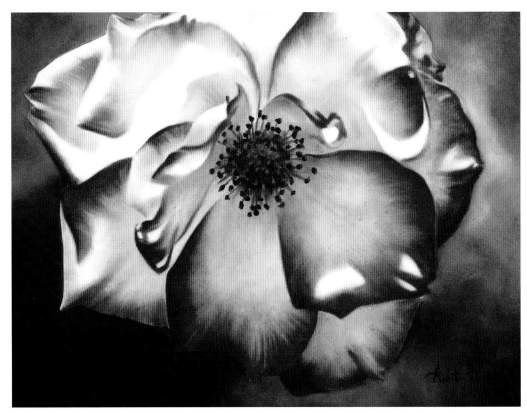

Rose Light ✿ 9" × 12" (23cm × 30cm)
Oil on board ✿ Collection of the artist

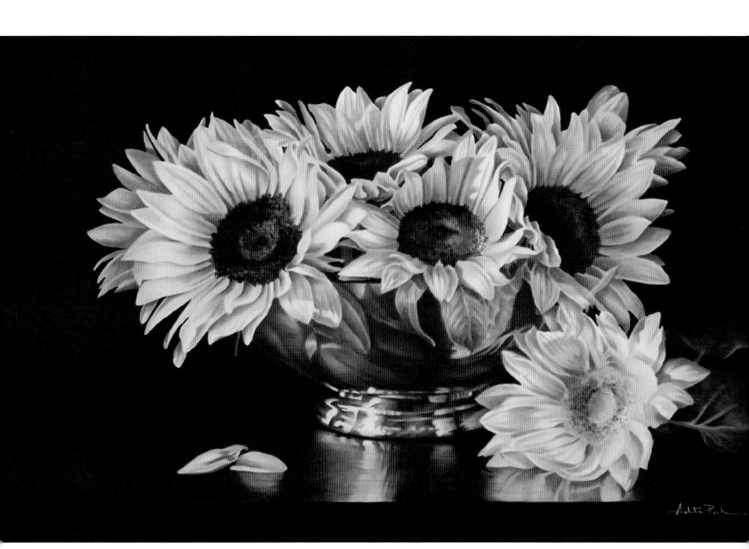

Golden Glory 🌻 14" × 22" (36cm × 56cm)
Oil on board 🌻 Collection of Tim Pech

Painting a Bouquet of Multi-Petal Flowers

The white highlights sprinkled throughout the sunflowers move the
eye through this painting. When you have this many multi-petal flow-
ers, decide which flowers are the most important. Which one is your
focal point? Which ones need to be glazed deeper to push them into
the shadows or the background? The petals farthest from the center
should be simplest, the petals near the center of interest should be the
most detailed.

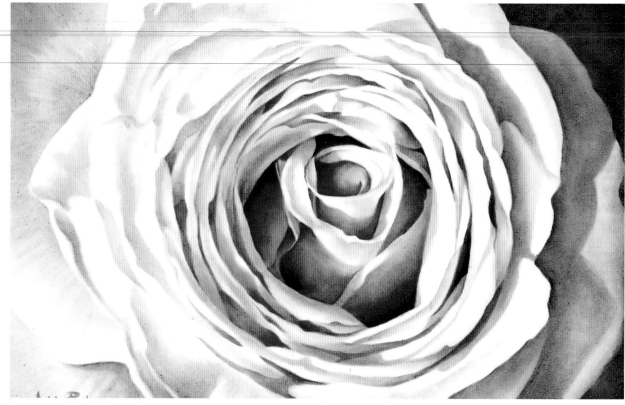

Embrace ✒ 6½" × 10" (17cm × 25cm)
Oil on board ✒ Collection of the artist

Focusing on Contrast
This rose was photographed in full sunlight. The cast shadows are strong and the deep rich colors of the blossom's center form a striking contrast against the white petals.

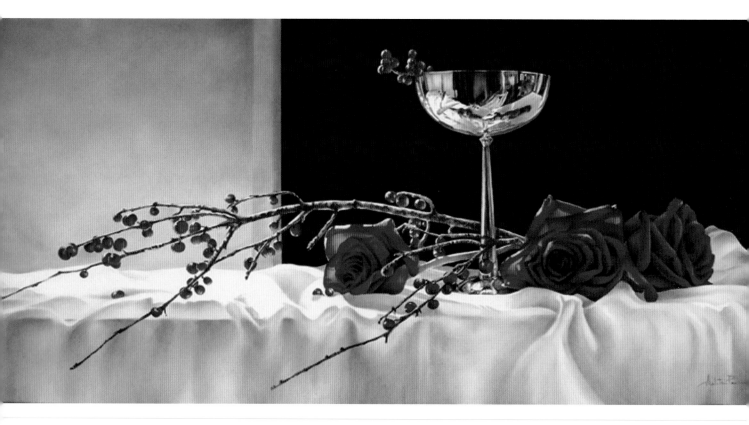

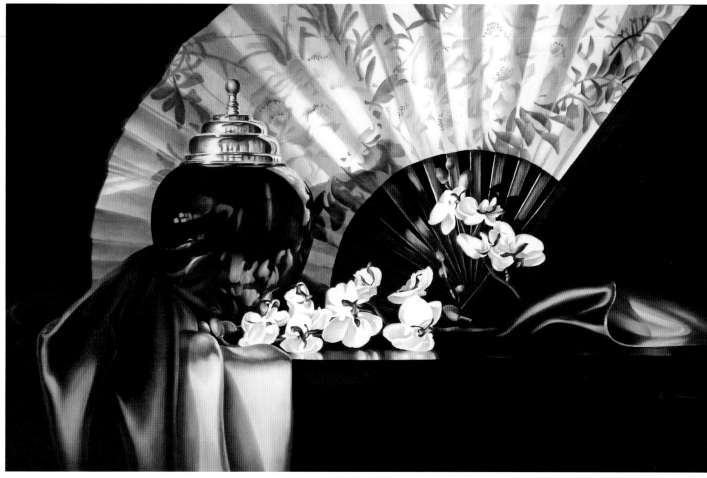

Touch of Silk ✿ 20" × 32" (51cm × 81cm)
Oil on board ✿ Collection of the artist

Painting Satin

Satin has similar features to creating sheer fabric. It has similar value structure, but much more pronounced highlights. The darkest areas of satin's folds create core shadows that flank the highlights. The folds help to break up strong patterns and keep the eye moving about the painting.

Give Each Berry a Unique Value Pattern of Light

Each winterberry was painted with the same process as the berries in the *Cherries, Raspberries, Berries* exercise on page 55–59. When painting clusters of berries, each berry will have its own value pattern created by the light. When painting berries, observe how the light affects each one and paint individual patterns for realistic results. If you painted the berries with the same value pattern just to get them out of the way, the effect of light would be destroyed.

Winter Berries ✿ 15" × 31" (38cm × 79cm)
Oil on board ✿ Collection of the artist

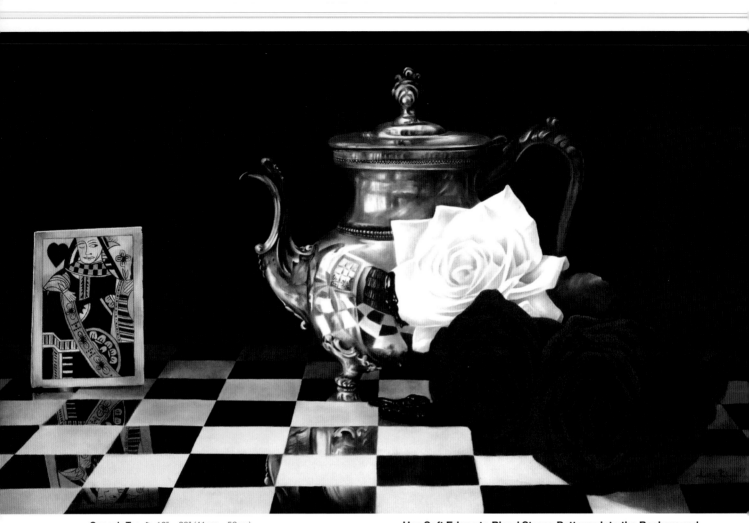

Queen's Tea ✦ 16" × 22" (41cm × 56cm)
Oil on board ✦ Collection of the artist

Use Soft Edges to Blend Strong Patterns Into the Background
When using a strong pattern in a painting such as a checkerboard, make sure to blend the edges between the pattern and background, so the pattern doesn't overtake the eye.

Painting Transparent Glass
The principles of transparent glazing are ideal for creating luminous glass. Remember to build your glazes slowly, let them dry thoroughly and save the whites of the canvas or board.

Red Wine Decanter ✦ 40" × 26" (102cm × 66cm)
Oil on canvas ✦ Collection of the artist

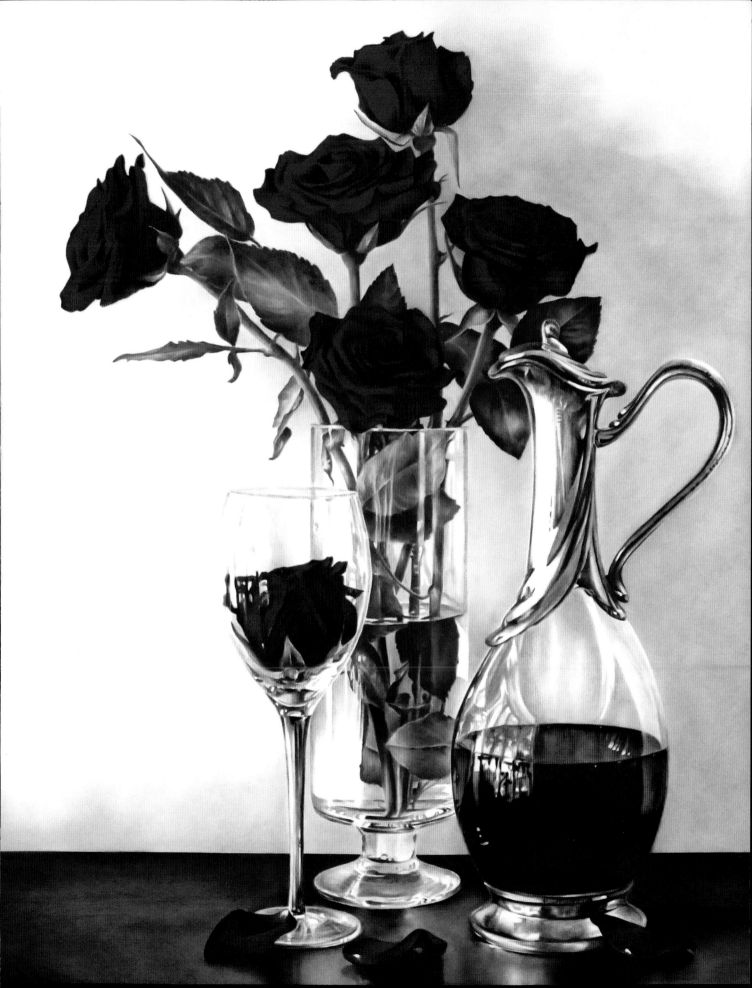

Conclusion

Writing my second book has been an honor. Since the release of my first book over a decade ago, it is exciting to share my processes with a whole new set of artists.

I'm a self-developed artist without a formal art education, and I learned to paint from art books just like this one, taking tiny pieces of knowledge from each book I read. I tried all the suggested exercises and spent hours and hours practicing. I still have all of those art books, and many times I return to them, whether to look through an old favorite or to recommend a title to one of my students.

Sometimes I simply stop and read remembered words that meant so much to me when I was a beginning artist struggling to learn and grow.

We are all on the same path as artists, some are just farther down the path. I hope you never stop searching for artistic growth, and

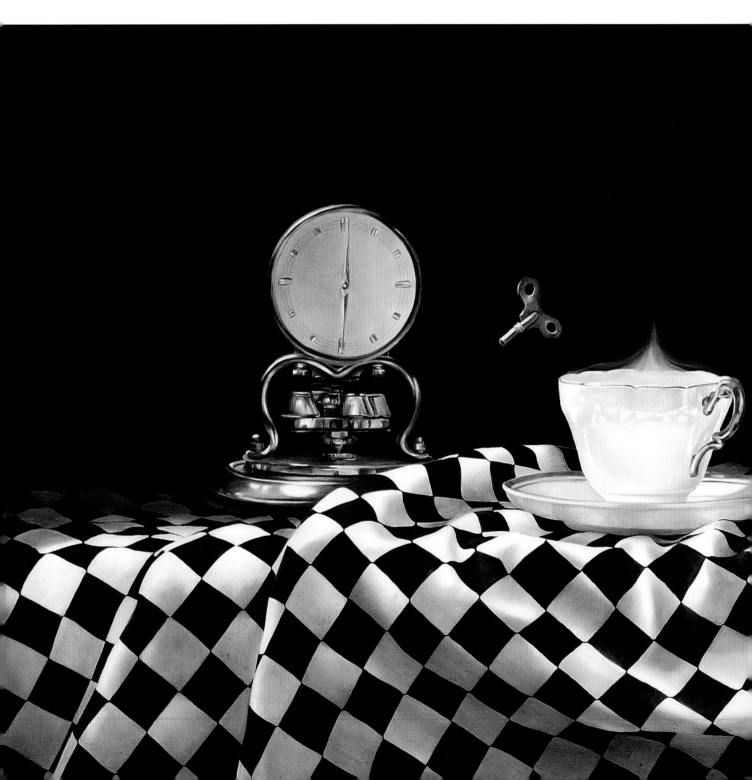

that this book adds to your skills, or
even to supply that special "Aha!"
moment. From one artist to another,
best wishes on your artistic journey.

Arleta Pech

Time Suspended 🌿 26" × 54" (66cm × 137cm)
Oil on hardboard 🌿 Collection of the artist

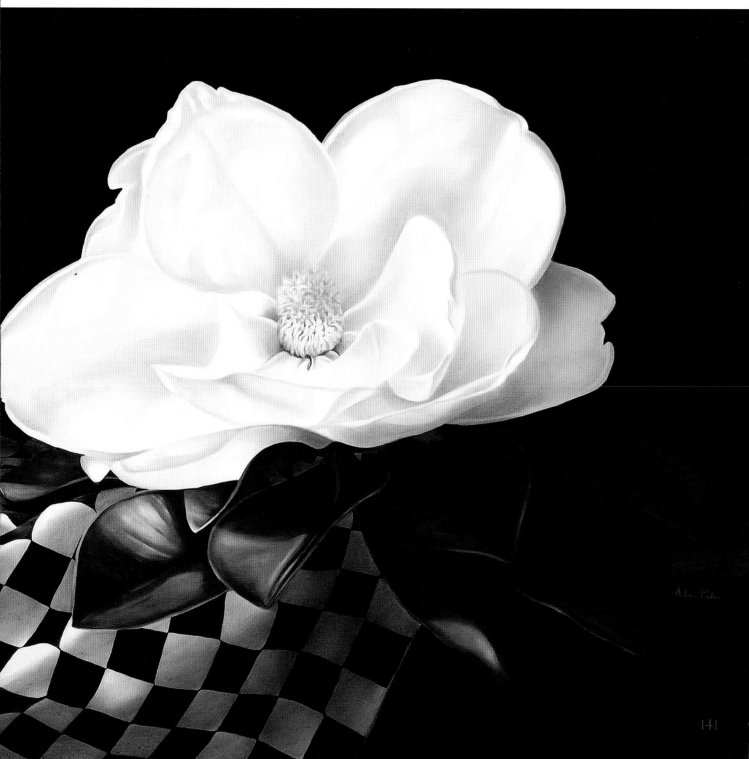

Index

apple, 75–79
artificial light, 27

background, 21, 78, 107, 110
 gradation in, 111
 lightening, 115
 paint, 12
 preparing for transparent glazing, 42
 strengthening, 87
 techniques, 35–39
 value adjustments, 114
backlight, 27, 81, 118, 123, 126
balance, 27, 52, 113, 114
banana, 75–79
berries, 55–59, 137
blending, 12, 39, 45, 52, 72, 84, 91, 100, 111
blocking in, 44, 45, 83, 90, 91
blueberries, 55–59
body color, 26
brushes, 11, 12, 13, 42, 45, 90, 96, 111

canvas, stretching, 16–18

cast shadows, 46, 57, 67, 84, 101, 119, 122, 126, 136. *See also* shadows
center of interest, 102, 103, 128, 135
cherries, 55–59, 118–25
cleaning, 13
colors
 background, 36
 building up, 78, 84, 108, 120
 cooling down, 67
 creating harmony, 97
 creating vibrancy, 77
 light transparent, 31
 mixing, 25, 29, 51
 perception, 30
 semitransparent, 61, 62
 transparent, 29, 51
composition, 27, 128
contrast, 136
core shadows, 137
crystal bowl, 90, 94–95

dab-and-blend technique, 72
daisy, 65–69

demonstrations
 folds and shadows, 106–17
 glazes in unique lighting, 118–25
 north light, 82–88
 painting a complex subject, 89–105
depth, 69, 101
details, 51, 66, 123
dimension, 47
drawing, transferring, 41, 89, 106
dressing, 12
drying, 47
dulling, 58

edges, 38, 39, 43, 45, 125, 138
 blending, 91, 100
 smoothing, 73
 softening, 52, 96
equipment and materials, 10–23
exercises
 rough texture, 70–74
 solid objects, 55–59, 60–64, 65–69
 transparent objects, 75–79

flame, 126
flowers
 gerbera daisy, 65–69
 hydrangea, 131
 magnolia, 86
 rose, 60–64, 112, 127
 sweet peas, 93
focal point, 26, 27, 69
folds, 81, 106–17, 137
foreground, 93
form, 31, 49, 56

gesso, 19
glare, 22, 23
glass, 90, 94–95, 138
glaze, 26
 painting subjects with, 54–79
 planning order of, 50
 thin value, 30
 thinning, 48

Timeless ❧ 16" × 20" (13cm × 51cm)
Oil on board ❧ Collection of the artist

transparent (*See* transparent glazing)
glazing viewer, 34, 52
glow, 92, 129
grapes, 75–79
grays, 33, 77, 83

hard edges, 43, 125
harmony, 50, 97
high-key study, 131
highlights, 19, 44, 56, 129, 134, 135, 137
hues, 37, 78
hydrangea, 131

interest, 37, 47, 69

leaves, 112
lemons, 118–25
light transparent colors, 31
lighting, 21, 22, 24, 27, 80, 118–25
limes, 118–25
local color, 26, 44, 45, 83
luminosity, 26, 46, 138

magnolia, 86
materials and equipment, 10–23
medium, 12, 14–15
mistakes, 43, 66, 125
mixing, 29, 51

negative space, 128
neutral color chart, 36
north light, 27, 80, 82–88, 129, 131, 134

oils, 25, 115
opaqueness, 26, 28, 30
optical glazing, 25
optical grays, 33, 127
optics, 26
orange, 70–74

paint
 storing, 102

thinning, 12
painting evaluation, 125
persimmon, 70–74
petals, 61, 65, 66, 68, 86, 93, 96, 105, 135
photography, 20–22, 98
positive space, 128
primaries, 32
priming, 19

raspberries, 55–59
realism, 24, 25, 114
red, 60–64, 130
reference photos, 20–21, 41, 44, 98, 114, 118
reflections, 48, 91, 95, 99, 107, 111, 127
rose, 60–64, 112, 127

satin, 137
scrubbing, 43, 45
semitransparent colors, 61, 62
shade, 27
shading, 77
shadows, 47, 81, 106–17, 133, 137. *See also* cast shadows
sheer materials, 106, 117
shimmer, 121
silver, 107, 109, 134
soft edges, 38, 39, 43, 45, 100, 138
solid objects, 55–59, 60–64, 65–69
spotlight, 80, 132
squinting, 71, 79
staining colors, 31, 87, 98
stippling, 39, 42
stretcher bars, 16
sunlight, 27, 127, 130, 136
sweet peas, 93

tape, 91, 92
techniques, 12–23
 background, 35–39
 transparent glazing, 44–53
texture, 70–74, 84
tints, 78, 95

Titanium White, 19, 43
tools, 11
transferring a drawing, 41, 89, 106
transition edge, 91
transparency, 26, 28, 81, 138
transparent glazing, 28
 color basics for, 32
 creating, 14
 defined, 8
 foundation of, 40–53
 introduction to, 24–34
 preparing background for, 42
 techniques, 44–53, 126–41
transparent objects, 75–79

values, 45
 balancing, 52, 113, 114
 building, 31, 55, 85, 108
 checking, 113
 deep red, 60–64
 deepening, 49
 delicate, 107
 diagrams, 119
 establishing, 85, 89
 range of, 117
 and semitransparent color, 62
 strengthening, 87
 warm and cool, 56
varnish, 23
vibrancy, 77

wet-into-wet technique, 50
white, 30, 133, 134, 135
white of the board, 19, 30, 76, 133
wipe out tool, 66